# PHOTOGRAPHIC TRICKS SIMPLIFIED

A MODERN PHOTOGUIDE

# PHOTOGRAPHIC TRICKS SIMPLIFIED

by

**The Amphoto Editorial Board**

**PRENTICE-HALL**
Englewood Cliffs, New Jersey 07632

**AMPHOTO**
Garden City, New York 11530

The following companies have cooperated
in the preparation of this book:

| | |
|---|---|
| *Typesetting:* | Radnor Graphic Arts |
| | Radnor, Pennsylvania. |
| *All paper:* | Westvaco |
| | Luke, Maryland. |
| *Printing:* | Hallmark Lithographers, Inc. |
| | Westbury, New York. |
| *Binding:* | AME Bindery |
| | Jersey City, New Jersey. |

# CONTENTS

## INTRODUCTION

Most cameras are purchased and used simply to take pictures—to record special family events, vacations, and so on. And, this is all to the good. But from the starting point of picture taking, many amateur photographers sharpen their photo technique to the degree that they soon can be regarded as picture *makers.* Special lenses, filters, and films together with an advancing knowledge of just how photography works all can combine to produce images marked by the imagination and creativity of their maker.

So-called "straight" or documentary photographers might well ask, "What is wrong with reality realistically presented?" The answer is simply enough, "Nothing." Realistic and documentary photography have served as invaluable recording and informational tools for well over a century. But, in recent years, adventuresome, creative photographers have begun to experiment with their medium just as painters of the late 19th century broke away from the tradition of representational painting to explore the varied avenues of abstract art. Abstract, personally expressive, photographic images now abound in advertisements and magazines. And, such novel photographs lie within sure possibility for any photographer willing to experiment.

Photographic tricks are the starting point for creative invention. By better understanding how the camera, lens and film work, and by learning how to use them in fresh, new ways, the photographer can exploit his medium to its full potential, limited only by the bounds of his imagination.

This volume, as well as other books in the series, was prepared under the supervision of Patricia Maye, Managing Editor of Amphoto. Ms. Maye also designed the book. Sheldon Czapnik, Judy Kiviat, and Penny J. Schwartz assisted in editing the text, and John C. Wolf, Amphoto's Editor-in-Chief helped with his knowledge and creative suggestions throughout the project. Special thanks is due to all the photographers whose photos are reproduced, especially to Andreas Feininger for his kind permission to use material from his books *Darkroom Techniques, Volumes I and II* (Amphoto, 1973) and *The Perfect Photograph* (Amphoto, 1974).

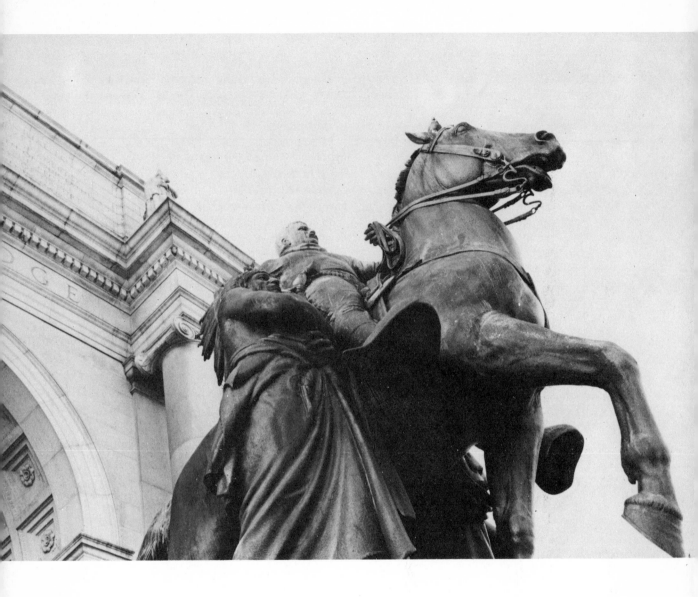

# 1

## THE CREATIVE CAMERA

*Despite the title of this chapter, the camera is powerless to create interesting pictures without the assistance of a creative photographer. In the picture at left, the sculpture was shot close up and from below with a wide angle lens. The horse's hoof is emphasized and the rider reduced in importance. Photo by Rafael Fraguada.*

# THE CREATIVE CAMERA

The versatility of your camera allows a variety of approaches to your own personal interpretations of the subject you photograph. If you are familiar with your camera and lenses and know what they can and cannot do, you can record your subjective impressions as well as the actual scene.

Through the selection of an unusual angle of view, you can convey to others a different image that gives a new "twist" to the material. Panning, racking, or shooting multiple exposures will also offer you the opportunity to express yourself in novel and refreshing ways. Motion studies will convert the subject into flowing streams of light. And, high and low contrast studies of exactly the same subject will produce extraordinarily different results.

Lenses, too, play an important role in creative photography. Perhaps you have already discovered the distortion of a wide-angle lens quite by accident—and had it work against you. Now, why not try to make it work *for* you to create an unusual photograph? Let's say you are going to take some pictures of a friend whose outstanding characteristic is his height. Why not exaggerate that height and create a photographic caricature of him? By shooting with a wide-angle lens up close and from below, you can elongate his body until he appears much taller than he actually is. Or, if you are shooting a particularly intellectual subject, you can climb up above him and shoot down to depict him with an enlarged head and diminished body size.

The use of the techniques in this chapter will help you to discover new ways of interpreting with your camera, to break away from the usual treatment of subjects, freeing you to give vent to your own creativeness.

## NORMAL LENS

The lens sold with the camera is generally called the "normal" lens for that camera. With the 35mm camera, for example, this lens is the 50mm (75–80mm for the 2¹/₄ camera), and its vision is considered to be closest to that of the human eye. These standard lenses will cover most shooting situations and give images that generally do not have the extreme distortion obtainable with wide-angle and telephoto lenses except, of course, at very close distances. However, it is possible to create "trick" effects even with your standard lenses through an unusual choice of perspective—the relative position and size of objects as governed by the viewing distance and angle of view. There is almost always a "best" point of view for each subject you wish to photograph, and part of the creativity of being a photographer

is to seek out that point and utilize it. For this reason, you should examine a subject from many angles before you decide which is "best." While circling the subject, moving back and forth and up and down, you will often come across other unusual positions that present the subject in a distorted or surrealistic manner. Providing this position helps to say something about your subject, you will have found the "best" perspective for a "trick" picture.

Unusual overlaps of images are, of course, to be avoided in straight shots. But, why not try an extra frame or two—for fun's sake—with that telephone pole or TV antenna emerging from a friend's head or his too-close-to-the-camera feet looking so enormous.

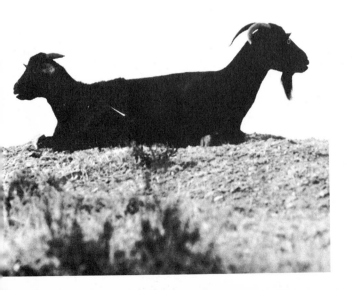

*The overlapping silhouettes of two goats here combine to produce a seemingly two-headed specimen. Exposure was made for the background sky and detail in the animals, which would have aided in determining where one left off and the other began, was decreased. Photo by Kathy Wersen.*

## WIDE-ANGLE LENS

For shooting in confined or crowded places and for greater depth of field, the wide-angle lens is ideal; it allows you to capture a larger slice of the scene without stepping back. While the normal 50mm lens has a 45-degree angle of view, a wide-angle lens of 25mm has half its focal length, and takes in almost twice as wide an arc. In the 35mm camera these lenses are available from 20mm to 35mm, and for the 2¼ camera, from 50 to 65mm.

Wide-angle lenses can and do produce seemingly wild distortions, though these are not really inherent in the lens itself. They are caused by the actual point of view from which the lens sees the scene. If lenses of different focal lengths are used at different distances to produce same-size film images of a certain object, the wide-angle lenses (short focal lengths) will seem to increase distances and dimensions, which cause close objects to look abnormally large. In contrast, telephoto lenses appear to de-crease distances and dimensions. This is purely a function of camera-to-subject distance but you can use it creatively to your advantage.

There are two ways to utilize the "distortion" ability of the wide-angle lens for unusual creative effects. The lens offers quite close focusing ability coupled with generous depth of field. By moving in close to the subject the foreground areas will appear unusually large and the background areas small by comparison. Thus, hands stretched out toward the camera can be recorded clearly and quite large. This can be further exaggerated by shooting from extreme angles. Shooting down or straight up toward a person will greatly enlarge the parts of the body closest to the camera—a technique often used for emphasis.

A second form of "distortion" occurs when the camera is not held parallel to the subject —particularly noticeable when photographing tall verticals. For example, were you to stand

*A 30mm lens provided the wide-angle of coverage and foreground emphasis apparent in this shot taken from on top of a train. Photo by Horst Schafer.*

close to a building and tip your camera up to include the top, you would achieve a picture in which lines converge and the building appears to be falling over backward. Again, this is no fault of the lens. If you stand close to a building and look up, you will "see" the converging lines. This can be corrected by holding the camera with the film plane parallel to the subject plane, and stepping back if you can't get enough of the building in. With an extreme wide-angle lens like the 21mm, the slightest tilt from a plane completely parallel to the subject will create extreme convergence, which you can use to create a novel view of familiar buildings, statues, or landmarks.

It is wise to know how to avoid these apparent distortions when you don't want them. But when you want an unusual effect, you can make these extremes work wonders for you!

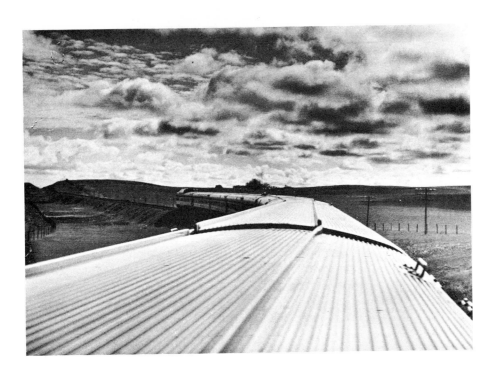

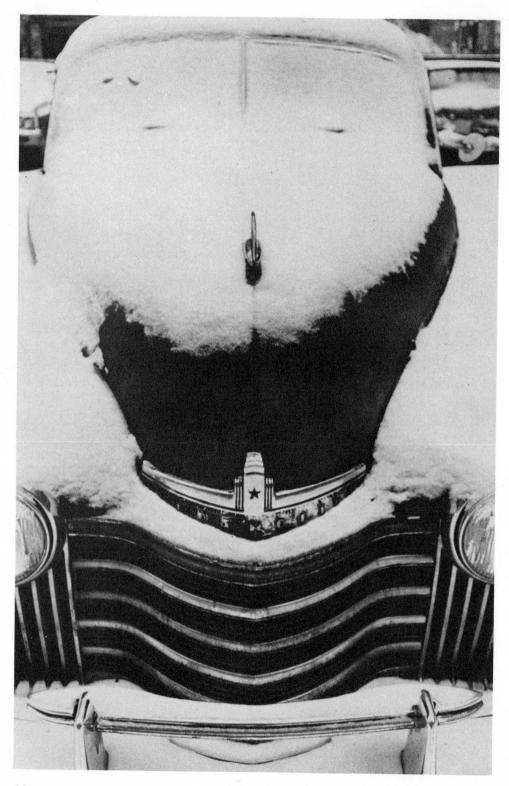

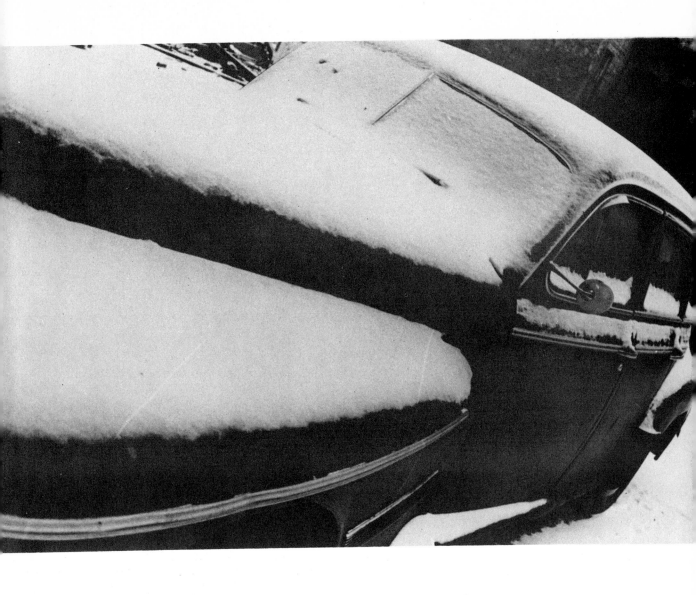

*A wide-angle lens was used at close quarters for these two photos of an old car in the snow. The wide angle's generous depth of field, even at close distances, is shown in the photo at left. The lens' elongating effect coupled with a novel angle of view contribute to the strength of the shot above. Photos by Rafael Fraguada.*

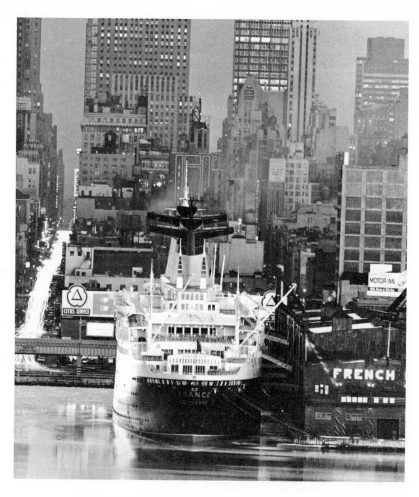

This telephoto view of a New York pier was taken from the
New Jersey side of the Hudson River. Because of the great
shooting distance, the spaces between the elements within
the picture are deemphasized. Photo by Gerald Healy/Photo
Trends, Inc.

## TELEPHOTO LENS

Some years ago a telephoto lens generally meant lenses within the 85mm to 135mm classification, with the shorter lengths being used for portraits and the 135mm length used for distant scenes that the photographer was unable to get close to. Today the 85mm to 135mm lenses are considered medium telephotos and lengths from 180mm to 500mm and even 1000mm are coming more and more into everyday use.

The longer focal lengths reduce the field of view and bring distant subject matter "closer" to the camera. Limited depth of field is an optical fact of life when using a telephoto but it can be used to isolate the subject from extraneous surroundings and thus create emphasis. And, because the telephoto allows for shooting from a distance, the spaces between objects in the shot are smaller in relation to the camera-to-subject distance and a compression effect can be achieved. Photographing a crowd of people from a distance, for example, will make them seem more jammed together than they actually are.

From the New Jersey side of the Hudson River, Gerard Healy created an unusual compression effect (page 16) with the aid of a 5×7 camera and a 1000mm lens. Notice the cross view of Manhattan from the street on the left and the compression of the city buildings against the background skyscrapers. The accordion effect of the "France" in the foreground almost makes it look like a toy boat rather than an ocean-going liner.

The light, long lenses of 180mm to 200mm can be hand-held with practice at $1/60$ second. And the lighter-weight models of the 300mm to 400mm lenses can be held at $1/125$ to $1/250$ of a second. Lenses longer than 400mm, however, require a sturdy tripod. Remember, the slightest movement will exaggerate picture blur. And, haze, even on a clear day, requires the addition of filters when you want a sharp picture simply because there is much more distance and atmosphere than normally between you and your subject.

## SELECTIVE FOCUS

In order to make full use of the creativity of selective focus, you must know how to make use of a camera's range of sharpness at any given distance and *f*/stop, and how these settings add to or detract from the primary subject. The choice of lens aperture governs two things: exposure and depth of field. The larger the lens opening, the smaller the *f*/number, and the more light it lets through to the film. Also, the wider open the lens, the shorter its depth of field. Thus, with wider open *f*/stops the photographer has the choice of throwing the foreground or the background out of focus according to where he wants his sharpest point of interest.

Depth of field is also affected by focal length. A wide-angle lens will have a greater depth of field than a telephoto lens at the same *f*/stop and picture-taking distance. For instance, a 35mm lens open to *f*/2 and focused to 5 feet will register everything acceptably sharp from 4′8″–5′5¾″; a 50mm lens will be in focus from 4′10″–5′2″; a 105mm lens from 4′11″–5′. Thus, if a photographer wishes to limit depth of field he can choose his longest lens for shooting that subject. The third factor affecting depth of field is camera-to-subject distance. Any lens offers a shallower depth of field at close range than at long range.

Careful use of selective focus will help you give an unusual treatment to the most usual subjects. Take, for example, the "Peeping Tom" shown below. To achieve such effects you can choose a large aperture (small *f*/number), shoot with a long lens, or approach your subject closely to minimize depth of field.

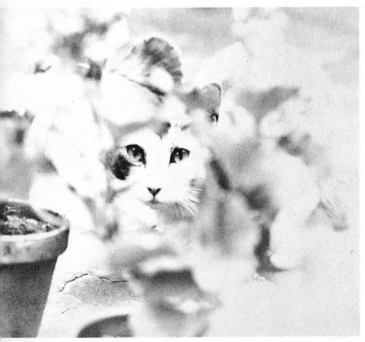

*The cat's eyes attracted the photographer to take this picture. In order to limit the in-focus area of the picture, she chose the widest possible aperture that her lens offered. The emphasis was heightened after the fact by enlarging the shot on high contrast printing paper with a normal printing exposure for the eyes and slight underexposure for the rest of the photo. Photo by Kathy Wersen.*

## OUT-OF-FOCUS IMAGES

Clarity—and as much of it as possible—is the overriding concern of many photographers and most beginners. But, many strange and delicate effects can be obtained by deliberately throwing the image out of focus. The picture shown below is an excellent example of extreme defocusing, though other ingredients contributed to the particular qualities of this shot. Defocusing is often used to exaggerate the unusual shapes produced by the flare of strong, contrasty backlighting, but it is also useful when an elongated effect is desired in either a vertical or a horizontal direction. In addition, it can be used to good effect in abstract pictures, especially on brilliant light displays, where a dreamlike and fantastic atmosphere is wanted. Out-of-focus effects can be created with a rangefinder camera, but it takes a twin-lens or single-lens reflex to preview the final image beforehand on the ground-glass screen.

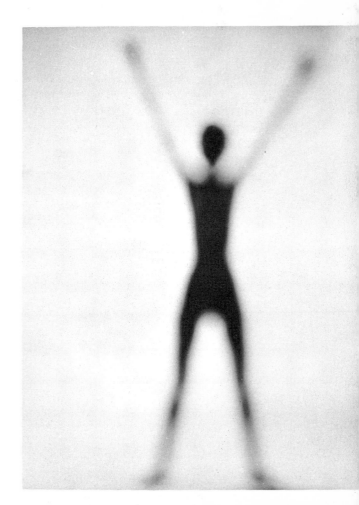

*This strongly backlit subject was deliberately thrown out of focus. The result is a wraithlike image. This shot was made in the studio with floodlights as the light source and white no-seam paper as a backdrop. Similar effects can be obtained outdoors by shooting into the sun with the sky as a background. Photo by Lester V. Bergman/Photo Trends, Inc.*

## SLOW SHUTTER SPEEDS

A still, central subject surrounded by a blur of action is emphasized in the same way as a sharp subject in a short plane of focus surrounded by a blur of foreground and background. In other words, slow shutter speeds are to the shutter speed range what selective focus is to the f/stop range on your camera. Imagine a dancer, momentarily poised on toe, with other dancers whirling around her, or a flower caught at a momentary standstill, while tall grass around it bends to the wind. Fast shutter speeds can freeze all the action, but slow shutter speeds more realistically capture the relationship of motion to stillness and the slight blur of action most often creates the more beautiful picture.

When we first begin with the camera we are told to get everything sharply in focus and without movement, or we will have blurry subjects. There are certain subjects that call for that kind of clarity. But with many others it means a static, dull shot.

Because there are 1001 frozen shots of musicians with their instruments or leaping dancers hanging in space, you may wish to try for a more subjective interpretation through the use of blur, or slow shutter speeds, by translating the patterns of jazz or dance into progressive patterns of light and motion. There is no real guide as to what shutter speed to use with what action, other than experience and experimentation. Using the shutter speed you would choose to freeze action, shoot at one, two, three, and perhaps even four speeds slower—then evaluate your results. You will discover some subjects are best interpreted by just a suggestion of movement, while others will lend themselves to wild, abstract patterns.

*The handsome photo on the opposite page is the result of a time exposure made while a helicopter landed. Lights on the rotor blades trace a lively pattern in the night sky.*
*Photo by Andreas Feininger from* The Perfect Photograph, *Amphoto, 1974.*

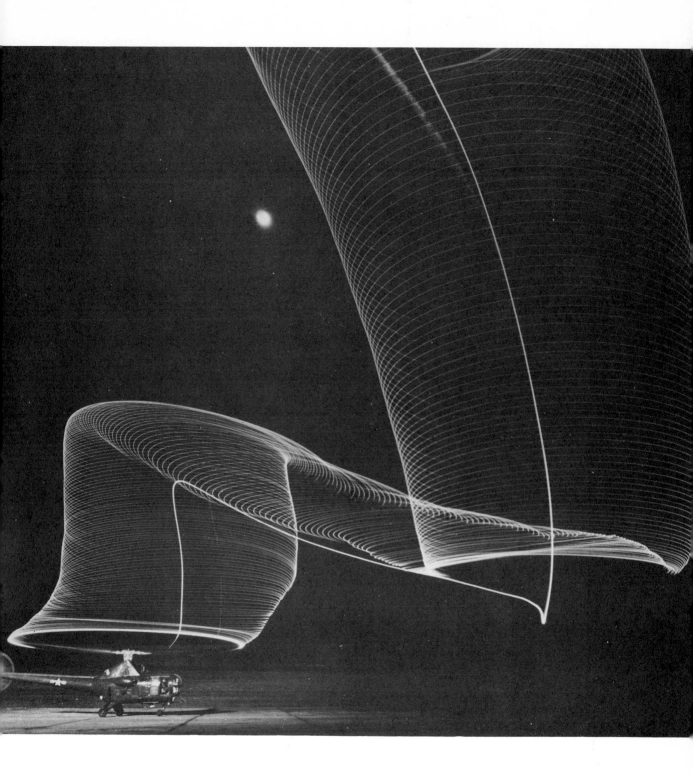

## RACKING

To create "out-of-this-world" pictures, two forms of racking can be utilized. Mount the camera on a tripod and use a slow shutter speed of ½ second or longer. During the exposure move the lens forward to the closest focusing point. This will create radial streaks. On the other hand, by racking the lens in toward infinity during exposure you can create a zooming pattern with blur more pronounced at the outer edges of the picture and less so in the center.

There is more control over center sharpness the nearer you work to the subject. Trial and error will teach you how much to rack out or in without disturbing your main point of interest. Use a very slow film and small f/stop in bright daylight to obtain the slow shutter speed needed. Or, you can use a neutral density or colored filter with a higher factor to cut the light and necessitate the time exposure.

Racking on or off the tripod can also be used for completely abstract effects. Particularly interesting subjects for this method are light sources at night and architecture.

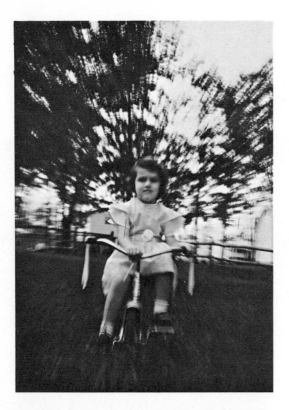

*The photos on this page demonstrate the effect of racking the lens toward the infinity setting (above) or toward the closest focusing distance (right) while making a time exposure. Photos by Gerald Healy/Photo Trends, Inc.*

## PANNING

The method of shooting a moving subject while simultaneously moving the camera parallel with the action is known as panning. The moving subject in the foreground will appear sharp and the background will blur into horizontal streaks, heightening the feeling of motion. Shots that would be impossible even at $\frac{1}{1000}$ of a second with a stationary camera can be captured by panning at surprisingly low speeds. Shutter speed is determined by the rate of the image crossing the film, not the speed of the subject itself. Thus, if your panning is accurate and you can maintain your subject exactly in the center of the viewfinder, almost any shutter speed can be used.

First practice following a moving subject by swinging the camera with it—keeping the image centered in the viewfinder. Then, while *moving the camera in the direction the subject is going*, snap a picture. Be sure you keep moving the camera *while* you are releasing the shutter. Many great pan shots have been flubbed because the photographer moved his camera up to the point when he snapped the picture, then, from force of habit, steadied his camera as he shot, achieving a blurred subject fleeing from his frame.

*Panning with the motion of the fencer reduced the background to a pattern of bright streaks. Photo by Horst Schafer.*

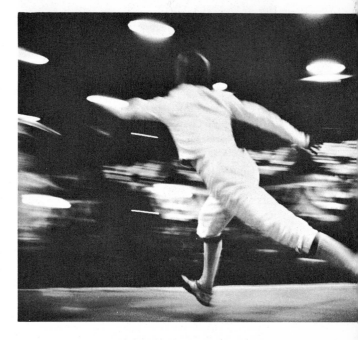

## MULTIPLE EXPOSURES

Perhaps as a beginning photographer you learned about the technique of double exposure the hard way and lost several otherwise good negatives in the process. Unplanned multiple exposures generally end up in the wastebasket—but consciously planned and carefully executed pictures of this technique will stimulate your photographic hours.

Lighting can be placed to illuminate each succeeding exposure evenly, or with variation. For instance, with a series of heads, the one farthest from the camera could be dimly lit, graduating to a normal bright exposure on the largest foreground head. Multiple exposures can be shot against a plain white or black background, but if you want the subject to overlap, it is best to use black for the background, with no light falling on it. This technique is best shot from a tripod, though the camera can be hand-held at fast shutter speeds if you are careful about subject placement.

Many modern cameras have double-exposure prevention built in. But with most this feature can be bypassed in one way or another. Once you get into multiple exposures it is easier to work with a ground-glass viewing system so each subject position can be marked on the ground glass with grease pencil. If you don't own this kind of camera, make a sketch of each position on a large sheet of paper and position the model with the paper as a guide. Sometimes it is better to move the camera, other times, the subject.

Lighting is usually kept simple and strong from the sides to avoid any spill on the background. Take the meter reading from the area in which you want the most detail. (With a portrait it would be the skin tones.) Give the same exposure to each position, unless you want to compensate for light fall-off in some of the positions.

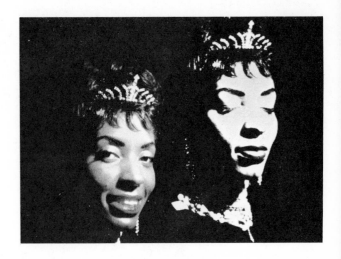

*The double exposure above was made by posing the model against a dark background. Normal portrait lighting was used for the exposure toward the left of the frame and high contrast lighting was used for the exposure on the right side. Photo by Norman Rothschild. The triple exposure below was planned out in advance and the model's positions sketched out with grease pencil on the ground glass of a view camera. Exposures for all three positions was the same. Photo by Lester V. Bergman/Photo Trends, Inc.*

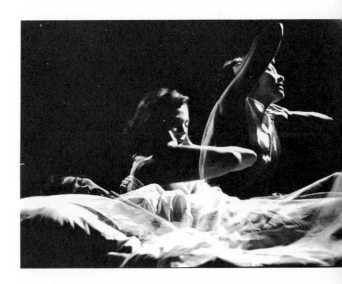

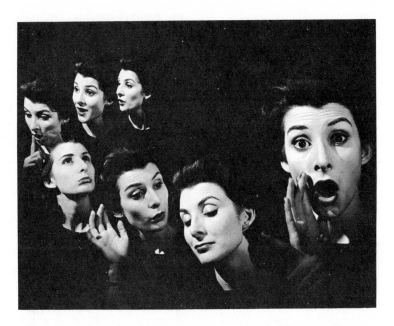

*The multiple exposure above was carefully planned to visually express the idea of "Gossip." Careful positioning of the model eliminated overlap. Photo by Lester V. Bergman/Photo Trends, Inc.*

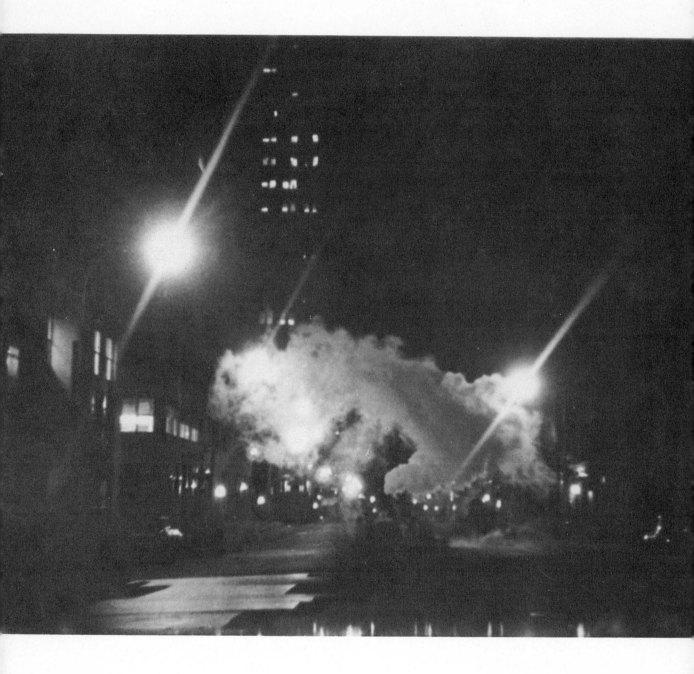

# 2

## BETWEEN LENS AND SUBJECT

*The inventive photographer develops a variety of materials to place between camera and subject to alter the image. For the photo at left, a grimy car windshield was enough to transform the street lights into bright stars. Photo by Patricia Maye.*

## BETWEEN LENS AND SUBJECT

Your initial investment included a generous outlay for a high-quality lens capable of producing top-quality, clear images. Tampering with the vision of that lens may seem pure heresy at first but it is a tested and sure way of producing original and inventive images.

There is a wide variety of materials you can hold in front of your camera lens to create startling photographs. Diffraction gratings, wire screens, Vaseline on glass, and cut-outs when held in front of a lens pointed at a light source will break the light into many different, fanciful patterns.

Shooting through a sheet of glass will add texture to a photograph and the many different kinds of glass available offer you a wide variety of textures to choose from. You can also achieve a texture effect by smearing the edges of a piece of glass with Vaseline, leaving the center clear so that your subject will be sharply in focus, with the background hazy or out of focus.

These additions to the camera are helpful tools for the unusual photograph. Let your imagination run a bit and use the techniques in this chapter as a jumping-off point.

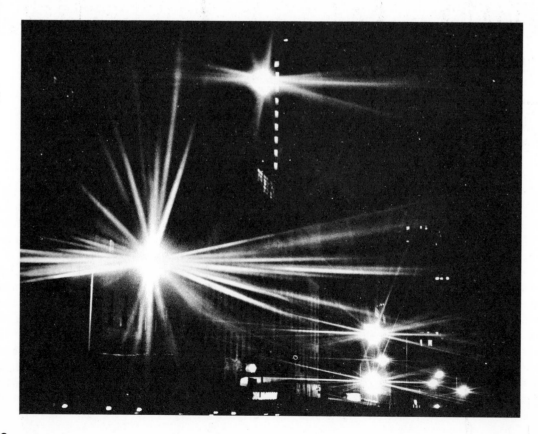

Three pieces of window screen were held in front of the lens to produce the elongated stars in the shot on the opposite page. For the shot above, two layers of nylon stocking were stretched over the lens and held in place with a rubber band. Photo opposite by Horst Schafer. Photo above by Patricia Maye.

## WIRE SCREEN

Star formations of varying points can be created by placing an ordinary piece of window screen in front of the camera lens and focusing on a bright light source, such as a street light. The screen can either be hand-held or cut to fit a filter holder that will screw into the camera lens. One piece of screen will break up a light source into a four-pointed star. Two pieces of screen held in a cross position will create an eight-pointed star, and so forth. If you use more than one layer of screen, increase the original exposure by $1/3$ for each additional layer added. By varying focus, from sharp, crisp images to out-of-focus ones, the star can be changed from a crisp, thin "X" to a short, fat, halo effect. The distance from subject to camera will also vary the star patterns. This is a simple way of bringing added emphasis to your night pictures.

To create abstract star-studded shots, try double, triple, and multiple exposures. This is especially effective in color shots where the dark background will be reproduced as a velvety black. Select a light source which is surrounded by dark masses, shoot it several times, framing each shot so that the light falls in an area that was previously recorded as dark, and you'll create a colorful pattern of bright stars against an inky backdrop.

## MAGNIFYING GLASS ON BELLOWS

With an SLR through-the-lens viewing system that accepts interchangeable lenses, interesting, soft-focus effects can be obtained by using a magnifying glass or supplementary close-up lens on a bellows extension. Remove the lens from the camera body and replace it with a bellows unit. Fasten the magnifying glass to the bellows with black tape. An optical magnifying glass can be used, but an easier optic is a supplementary close-up lens, which is also a form of magnifying lens, and may be found at any camera store for a few dollars. A +10 supplementary close-up lens has a focal length of about four inches; a +7, a focal length of about six inches. To find the f/stop, divide the diameter of the opening in front of the bellows into the focal length of the magnifier.

If you do not know the focal length of your magnifier, focus to the best of your ability on a distant object at infinity. The image will appear somewhat soft and fuzzy on the ground-glass screen. Then measure the distance from lens to film plane to find the focal length. These simple lenses transmit about twice as much light as a multi-element camera lens, so use the next higher (faster) shutter speed.

In the picture shown below, Norman Rothschild used a +10 Spiratone supplementary close-up lens of approximately a four-inch focal length. The diameter of the opening in front of the bellows was about 1 1/2 inches. Therefore, 4 divided by 1 1/2 gave an opening of about f/2.8. Rothschild set the ASA at 32 for his color film then metered the scene and found a shutter speed of 1/250 opposite f/2.8. The actual exposure was made at 1/500 second or 1 stop faster to compensate for the simple lens.

To get the exact effect you want, some experimentation with exposure will be necessary. (Bracket through changing the shutter speed.) Soft focus, particularly in color, always looks weak if overexposed, so work for deeper color saturation by slightly underexposing. Also, focus and shoot subjects no closer than three feet, or a close-up compensation of more exposure is required. A one-stop shutter speed increase is usually applied to any magnifying glass used.

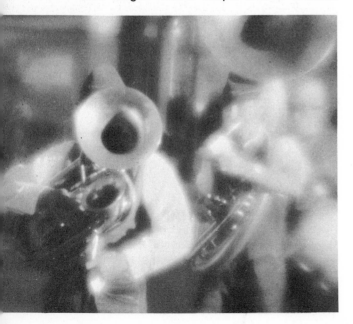

*An amusement park band was the subject for the photo at left. The shot was taken through a +10 close-up lens mounted on a bellows. Photo by Norman Rothschild.*

## PINHOLE-LENS COMPENSATION

By making a 1mm hole in a piece of cardboard and attaching this in front of your camera lens, it is possible to make extreme closeups and to get sharp pictures with a great depth of field. One millimeter equals $\frac{1}{25}$ of an inch. You can make a hole this size with a #60 drill—but be sure to smooth out the edges of the hole. Then cut the cardboard to the size of your camera lens opening and mount the aperture against the front surface of the lens, being sure to center it carefully. Do this after you have first focused on your subject with the lens wide open.

With this attachment in front of the lens, the f/number becomes the same as the focal length of the lens in millimeters. For example, a 50mm lens with a 1mm hole in front of it equals an f/50 opening; a 135mm lens equals an f/135 opening.

Take a normal meter reading and figure the shutter speed in relationship to the new f/opening. Bracket exposures and take notes, then compare these with your results to be sure your computations are correct.

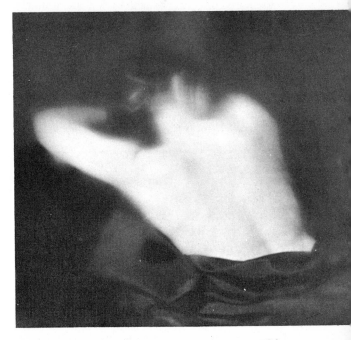

*A Vaseline smeared glass was mounted about six inches in front of the lens in order to achieve the image softening effect shown below. Slight overexposure flattened out skin tones and emphasized the dream effect. Photo by Lester V. Bergman/Photo Trends, Inc.*

## PETROLEUM JELLY ON GLASS

By placing a piece of glass or a filter in front of the camera and smearing its outside (leaving the center area clear) with Vaseline, you will be able to create many interesting and often romantic effects. (See the Renoir mood shown at the right.)

In addition, this technique, sometimes referred to as vignetting, is also useful for eliminating distracting backgrounds and centering interest upon the subject. This is another way of achieving selective focus. Usually no compensation is made in the meter reading for the glass in front of the lens. If you use a colored filter for some special color effect simply adjust your exposure to the filter factor.

## PRISMS

Prisms in front of the camera lens can create many amusing effects, as well as photographs of abstraction and design.

Use either a single-lens reflex, twin-lens reflex, or view camera so you can preview the exact results desired on the ground glass. With a twin-lens reflex, since the viewing and taking lenses are at different heights, place the camera on a tripod with a moveable center post. Measure the distance between matching points on the viewing and taking lenses. Focus on the subject through the camera and prism suspended in front of the camera lens. Mark the distance between the two lenses on the tripod. Rack the tripod up to the measured distance so that the taking lens is now where the viewing lens used to be and you are ready to shoot.

Many variations can be created by changing the placement of prism or the background subject. Also, you can use prisms with more or fewer sides; vary the subjects of the picture as well as background color and texture. Chandelier pieces found in antique stores will give you a great variety of prisms to experiment with.

## DIFFRACTION GRATING

Diffraction gratings are sheets of clear acetate with lines embossed upon them which diffract or break up light into different patterns according to the grating used. You can see exactly what a grating will do when you hold it up to a point light source and look through it. By placing a grating in a filter holder in front of the lens, or hand-holding it, you can create many interesting and extremely unusual pictures when photographing light sources. In black and white such effects are startling; in color, breathtaking. These gratings come in many variations, and half the fun of using them is in the experimentation.

Since each grating presents a slightly different exposure problem, bracket exposures over and under and keep scrupulous notes during your first use of a grating. Match your notes to the best result to establish a filter factor or exposure increase for each individual grating. As a general rule opening up one stop will provide enough compensation.

Diffraction gratings can be purchased from most optical companies. Or, you can write Edmund Scientific Company, Barrington, New Jersey, for their free catalog. They sell a diffraction grating kit with a large selection of $5\frac{1}{2}'' \times 8\frac{1}{2}''$ gratings that can be cut to size.

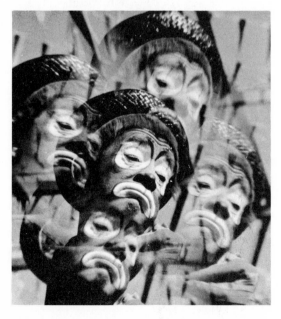

*A five-faceted prism produced this multiple image of a clown. Photo by Norman Rothschild.*

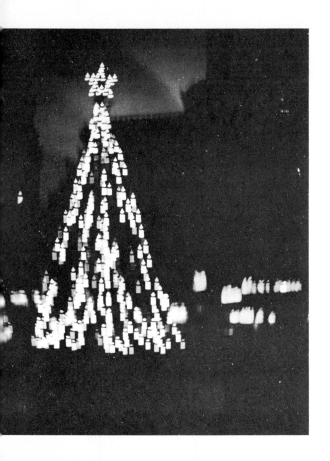

The multiple images above were produced by a single Christmas tree. By shooting through a 5000 line diffraction grating the photographer multiplied his subject. The clear tree was registered through a clear space in the grating. Photo by Norman Rothschild.

A candle-shaped cutout held in front of the lens lent its shape to the lights on the Christmas tree. Photo by Norman Rothschild.

## CUT-OUT EFFECTS

The unusual picture by Norman Rothschild (lower left) was made with a cut-out in the shape of a candle placed in front of his single-lens reflex. The pattern of the cut-out opening is produced from each point source of light when the camera is thrown out-of-focus. To try this, cut a design such as a star, diamond, or flower out of a thin cardboard, opaque paper, or a piece of fogged and outdated film that has been developed to black. The cut-out area should be smaller than the lens opening. Make the cut-out to fit a filter adapter or filter holder, or tape it or hold it in front of the lens. Open the camera lens to its widest opening. The cut-out now serves as a substitute diaphragm and is usually equivalent to an f/5.6 or f/8 opening depending on how much light the cut-out will admit. Since metering the light acceptance of the cut-out design and of a point light source is next to impossible, the best way to arrive at exposure is by bracketing, taking notes, and determining the best f/stop–shutter speed combination for future shooting with each individual cut-out. As a beginning, Norman Rothschild has found that with a 64 ASA film cut-outs that admit quite a bit of light average f/8 at ½ to 1 second. Those that admit a little less light average f/5.6 at ½ to 1 second. Thus, with a 125 ASA film exposures would run f/8 or f/5.6 at ¼ or ½ second, etc. Remember that the camera's lens is wide open and the light points to be photographed must be thrown out of focus for the cut-out design to register. When using a twin-lens reflex, first hold the cut-out over the viewing lens to plan the scene. Then place it over the taking lens when snapping the picture.

## SHOOTING THROUGH GLASS

Various surfaces of glass or plexiglass can be used between the camera and subject to add texture and to create photographs from the impressionistic to the abstract. In Bergman's picture of the model partially behind glass, shown here, you can see how glass distorts and dissolves the image. Note the appearance of the thumb and its clarity as compared to the face, which is about one inch behind the glass. The farther the subject is positioned behind the glass, the greater the abstraction will be. A pebbled surface will register more abstraction than a smooth surface. The viewing system of a single- or twin-lens reflex will show you what your final result will be before shooting.

The girl in a tear drop is a variation of shooting through glass. Here, instead of shooting a live model through a sheet of glass, a photograph and a glass drop were used. A glass rod was heated over a burner until it began to run. When a drop formed, it was allowed to cool. Next, a photograph was hung upside down on a white surface and the camera set on a tripod, pointed toward the picture, with the glass drop hung directly in front of the camera lens. The glass drop was moved in front of the camera until it framed the picture behind it. Then, the focus was set on the image in the tear drop. The glass drop acted as an extreme wide-angle lens.

Such a picture in a tear drop is only one of many variations of shooting through glass. Why not experiment and see how many other variations you can discover?

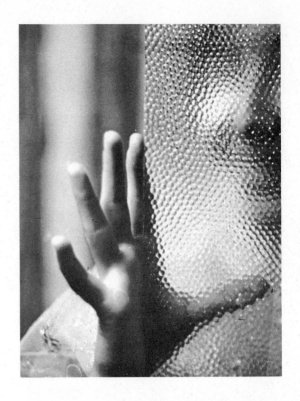

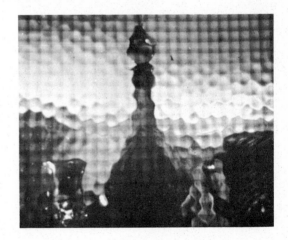

*The picture at the top of this page demonstrates the increasing softness the further the subject is positioned behind a textured glass. The shot directly above shows the impressionistic effect possible when a rougher texture glass is used. Photos by Lester V. Bergman/Photo Trends, Inc.*

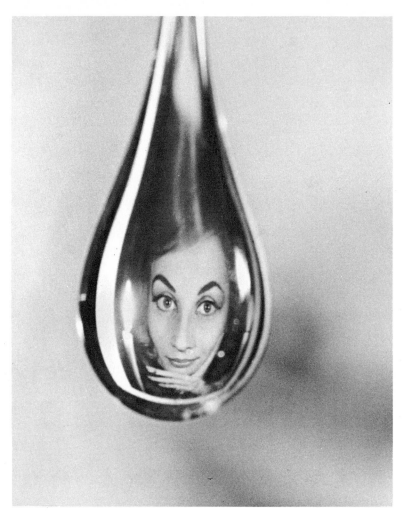

*A drop of glass, melted from a glass rod, forms a tear-shaped lens through which a photo of the woman was reshot. Photo by Lester V. Bergman/Photo Trends, Inc.*

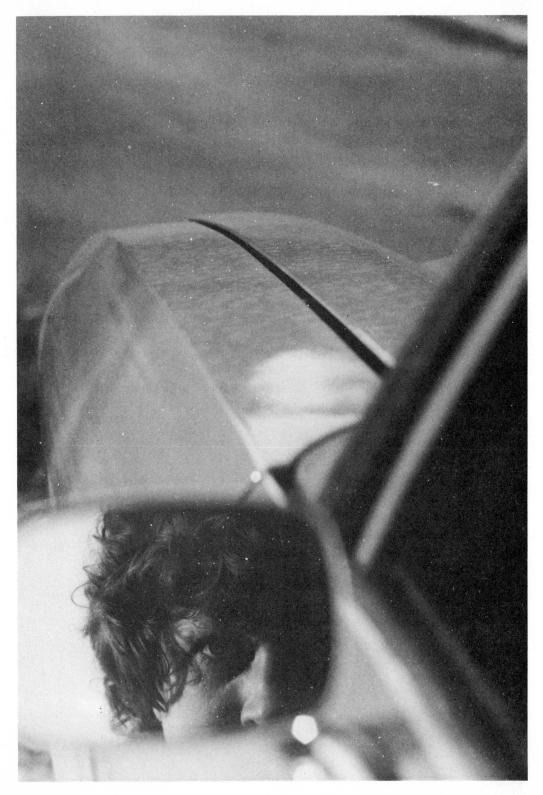

# 3

## CREATIVE USE OF LIGHT

*The watchful photographer will find subjects for his camera in unlikely spots. The image in the side mirror of the car is the photographer herself. She spotted and shot it while wandering about looking for a subject. Photo by Patricia Maye.*

## THE CREATIVE USE OF LIGHT

Without light we would have no photographs, for photography is literally "light drawing," and the incorrect use of light is probably one of the biggest gremlins to those who work with a camera. Merely by changing the lighting on a subject you can come up with an unusual photograph—but if you want to go a step further, the conscious, creative use of light will present you with much more than some truly unusual pictures. By studying the techniques described in the following pages, your appreciation of light will grow along with your ability to use it creatively.

Many photographers are so busy shooting their family, pets, and friends that they fail to see the subtle nuances of light—the beauty of an unusual angle of light, a shadow, or a reflection. Nature has her own special way of presenting things, her own special sense of humor. You can capture these different moods through the use of light. You can also control light to create original effects of your own.

## SHADOWS

For most beginning photographers shadows are something in which to seek refuge from the sun. It generally takes quite a while to see shadows as photographic subjects. You can find all sorts of interesting characters from outer space in the early morning or late afternoon sun. Sometimes shadows form fuzzy black replicas of their origins; other times they seem to take on shapes totally unrelated to anything near them, giving a feeling of mystery, humor, or fantasy. In combination with human or other forms they add excitement, interest, and three-dimensionality to pictures.

Meter for the highlights so that the shadows will go sufficiently dark and you'll produce pictures that only you have seen.

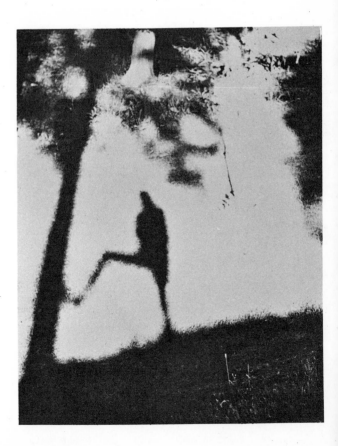

*The shadowy self-portrait at right is the photographer's silhouette photographed in the water. Photo by Horst Schafer.*

## SILHOUETTES

*The stark shapes above were produced by making a meter reading and exposing for the bright background sky. The resulting high contrast negative was further strengthened by printing on high contrast enlarging paper. Photo by Horst Schafer.*

Shooting directly into bright light or a light source such as the sun or an incandescent bulb, with the subject between the light source and the camera, will create a silhouette. This is also known as backlighting because the light comes from behind the subject. Consequently these pictures will always be of high contrast, which can be even further emphasized by using a contrasty film and/or high contrast, high number printing papers.

In the picture at left, Horst Schafer used Plus-X, which is considered a medium contrast film, carefully underexposed, and then printed on the most contrasty paper available, Agfa Brovira #6, to achieve a startling black-and-white design that looks like it had been recorded on a high contrast copy film. If he had given a normal exposure, he could have recorded every detail in the scene. This illustrates how much control the photographer has over his medium through his choice of exposure and printing paper.

To produce strong silhouettes, take the meter reading from the lightest area of the picture and also shoot at one and two stops less. By studying your contact sheets or blow-ups you will see the different degrees of silhouetting available through careful use of the exposure meter.

A silhouette is usually a picture of strong design—and yet at the same time gives you a peaceful feeling by eliminating the extraneous.

*The snow and bright sky emphasize the stark shapes in these two photos. Contrast was emphasized in printing. Photo opposite by Rafael Fraguada. Photo at right by Patricia Maye.*

## REFLECTIONS

Fascinating reflections can be discovered in many surfaces. Water is one of the most popular because slight movement can add further distortion and create original subject matter. In addition, all forms of glass, shiny metal surfaces—such as hub caps—and even polished marble walls will reflect unusual shapes. These reflecting surfaces, in combination with conditions of atmosphere and lighting, can alter reality into the most surprising images. There is usually one ideal angle of view for shooting reflections, so check your subject carefully before making that final exposure. Meter for the actual reflection and also shoot one and two stops less, for reflections tend to bleach out. When it is impossible to get close to the reflection, take the meter reading from a subject near you with approximately the same light value.

Reflections are best interpreted in a high contrast ratio, so use high contrast, fine grain film when possible (for example, Adox KB-14 or Kodak Panatomic-X) and print on the high contrast printing papers.

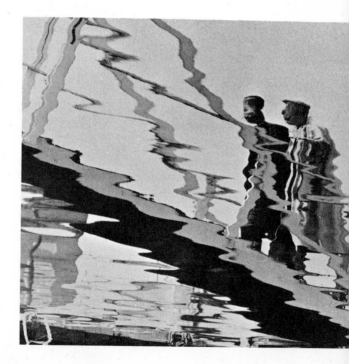

*Two people crossing a bridge were photographed in the moving water. The water's motion lends a further air of mystery to the photo. Photo by Horst Schafer.*

This surreal view was photographed in an automobile hubcap. The little girl in the foreground is the photographer's daughter intently watching what her father is up to. Photo by Horst Schafer.

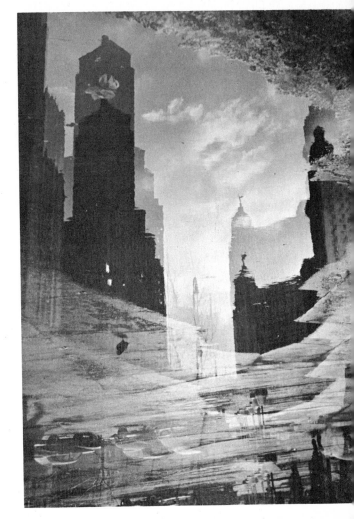

These buildings were photographed in a puddle in a New York street. The view included pedestrians who were cropped from the final print. The print is reproduced here upside down. Photo by Mary Eleanor Browning.

## STRIPED LIGHT

Here is a really unusual way to use lighting for artistic trick effects. In order to make pictures using this technique, first draw a series of parallel lines on a piece of white paper, then photograph it on high contrast copy film to eliminate the middle tones. Develop the film and mount it for projection. Place the model in front of a black background and project the slide of parallel lines onto the model with a 1000 or 500 watt slide projector about 45 degrees to the right of the camera. The closer to a parallel position the projector is with the camera, the flatter the body form will be. The nearer the projector is placed to a right angle with the camera, the more exaggerated the body form will be. Thus, by moving the placement of the projector you can vary the pattern of lines.

To determine the exposure once the subject and projector are set, remove the slide and read the projected light, then give one stop more exposure than indicated. Variations on this theme can be created by making different slide patterns, adding additional lights, such as a silhouette light behind the subject, varying the background color, using inanimate subjects such as glass objects as well as human subjects, or projecting the pattern on the background behind the subject.

*The striped nude on the opposite page was produced by projecting a slide of parallel lines onto the model who was posed in front of a dark background. The projector was positioned at a 45 degree angle to the camera. Photo by Lester V. Bergman/Photo Trends, Inc.*

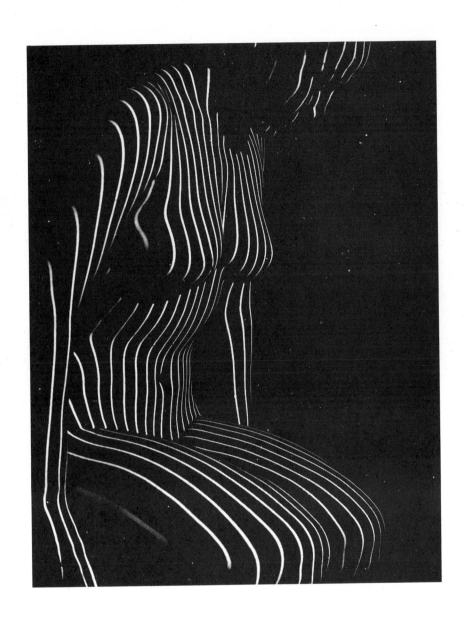

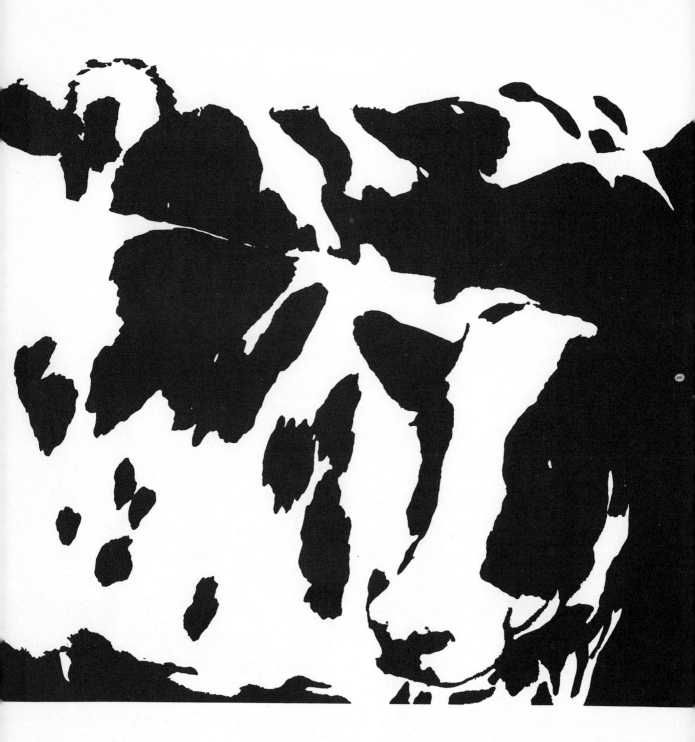

46

*The handsome, high contrast, black-and-white cows opposite were produced through darkroom manipulation. Photolith film was used to eliminate all middle tones. Photo by Otto Litzel from* Litzel on Photographic Composition, *Amphoto, 1974.*

## THE CREATIVE DARKROOM

To hear some people talk, one would believe that the art of photography begins and ends with the camera. Those who follow this belief miss out on at least half the fun and creativity of photography, for no matter how well you have planned a picture, or how carefully you have taken it, it is worthless unless the same care goes into the processing and printing.

The darkroom offers many techniques for turning "normal" negatives into wild and beautiful fantasies. You can take a twilight scenic and turn it into day or night, or change the conception of a photograph through easel movement or multiple printing, or integrate two shots into one by double printing. Design can be added to a picture through reticulation, grain exaggeration, or by placing a piece of textured glass or a texture screen over the enlarging paper. You can drop out all middle tones to create a charcoal or line drawing effect.

Other fascinating ideas can be executed in the darkroom *without* a negative. Through the technique described on pages 62–65, you can create any number of pictures just by placing objects on top of a sheet of enlarging paper and exposing it to the enlarger light.

By solarizing a negative or a print you can produce mysterious, sometimes ominous photographs. The possibilities of darkroom creativity are endless. If you haven't yet discovered this aspect of photography, you have a lot of fun in store. For those of you with experience, perhaps one of these techniques will be just the answer as to how to produce a dazzling print from that problem negative you've been pondering.

## GRAIN

With all due respect to those who have admonished photographers about the undesirability of grain in a photograph, the creative, intentional use of grain will enhance many of your pictures.

All photographic images are produced by the exposure to light of film coated with tiny grains of silver salts. These grains can be emphasized by choosing a grainy high ASA film, by push processing during development, or by gross enlargement of a small section of the negative.

The ultra speed films, such as Agfa Isopan Record, Ilford HPS, and Kodak Royal-X Pan or 2475 Recording Film, will produce large grain. Another method of achieving increased grain would be to expose these same films about one stop under their normal ratings and develop in Agfa Rodinal 1:50. Develop

*The portrait opposite shows the grain effect possible through overdeveloping and then printing on high contrast enlarging paper. Photo by Patricia Maye.*

Agfa Record for 12 minutes at 68 degrees F., HPS for 10 minutes at 68 degrees and Royal-X Pan for 13 minutes at 68 degrees for a thin, flat negative. Then, use a grainy intensifier such as Kodak Chromium to build up a fairly dense image on the negative. This also builds contrast. Print these negatives on a very high contrast paper for really unusual results. The grain of normal negatives can be increased just by printing on hard papers such as Kodak Kodabromide #5 or Agfa Brovira #5 and #6. Grainy developers, like Microphen and Rodinal used in a low dilution, will increase grain. Negatives which are overexposed, then developed to a good density, will exaggerate grain in almost any developer—most particularly, undiluted Microdol.

## CROPPING

When you think of tricks in photography you need not only think of unusual methods to arrive at unusual pictures, but also of the use of creative vision to transform a straight picture from the contact sheet into a trick photo. To learn the art of cropping requires experimentation, daring, and the return to old pictures many times as your eye improves with camera practice and work in the darkroom. The accompanying Martha's Vineyard scenic is an example of the last point.

Kathy Wersen made the original picture at the bottom of this page early in her photographic career. Two years later she made the second cropping and printed for a higher contrast effect. Later again she saw the thin horizontal cropping. The last picture to present itself is a tiny section out of the center of the original scene. All of this took place over a six-year span of time. Perhaps still others will emerge in the future.

Why not go back to some of your old prints and by blocking out different sections with two "L" shaped pieces of paper, see if you can find a stronger picture within the picture—and perhaps a more effective way of printing it. Practicing this variation on a theme is one of the best ways to learn the art of imaginative interpretation.

*The shot below is the first print made from the frame. The three alternate croppings opposite show the various treatments possible with a single picture. Photos by Kathy Wersen.*

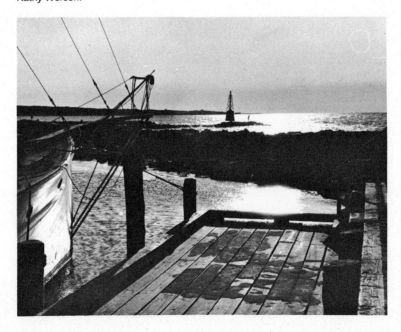

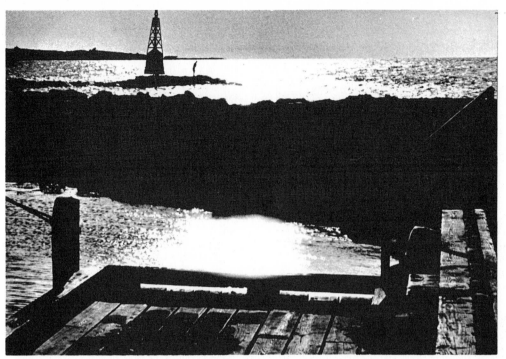

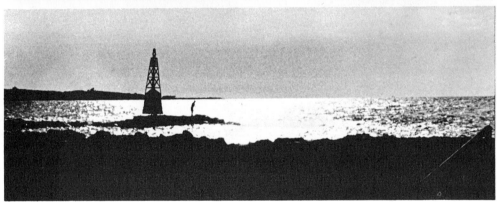

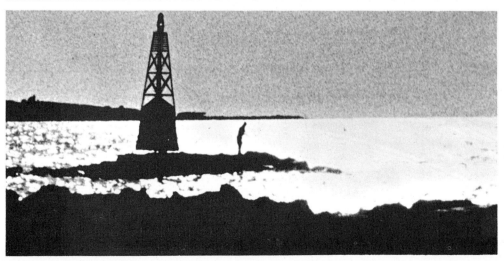

## EASEL DISTORTION

Just as tilting the easel will offer you the opportunity to correct distortion present in a negative caused by camera tilt (buildings falling over, etc.), it can also be used to create distortions that will intensify a mood for a specific pictorial effect.

The easel should always be exactly parallel to the negative when making a print in the normal manner. Because it is parallel, each part of the print receives the same degree of magnification. Easel distortion comes from tilting the board so that the projection distance from one side of the negative is increased and uneven magnification results. Tilting elongates the image in the direction of the tilt. The greater the angle, the longer the image is stretched out. And the enlarged image is bigger at the bottom of the incline than at the top.

Block up one side of the easel in order to obtain the degree of tilt you desire. As a result of the tilt, part of the projected image will be thrown out of focus. Stop the lens down to a small opening to increase depth of field and thus restore overall sharpness. Because focusing becomes a problem as soon as the paper is moved from a flat position, focus on a point midway down the incline, or in the center of the paper. Because the short side is nearer to the lens, it will receive more light than the rest of the paper. In order to attain the same tone quality over the entire print, make a test strip for both top and bottom and then expose for the longest time. As soon as the top has received sufficient exposure you can dodge it while the rest of the paper is being exposed.

To create a convex effect (a large nose, for example, in the center of a small face), use a concave sheet of paper (bent down in the center). The center of the paper will be further from the enlarger and the image will thus be larger in the center. For a concave image, bend the paper into a convex shape by curving it up in the center.

Other unusual effects can be created by making rippling distortions in which the image is alternately thick and thin. These are obtained by buckling the paper into grooves and pinning it into position. Be careful that the grooves are not so high that they cast shadows onto the rest of the paper, or the image in the shadowed areas will appear fogged on the final print.

Another form of distortion with the easel comes from moving it in a semi-circle to create swirling movements, as Kathy Wersen did for the bull-fight scene (page 53). With the test strip method, determine the best overall exposure. Stop the lens down for sharpness and use one grade higher contrast filter or paper than you would use for a straight print, for tonal values tend to flatten out with this technique. Divide your overall exposure time by the number of easel positions you plan to use. For example, suppose a test strip shows 24 seconds to be the best overall exposure time and you want to place the easel in six different positions. Twenty-four divided by six equals four seconds for each position. However, in position number one—the position in which you would place the easel for a normal print —it is always best to double the exposure time in order to obtain a sharp image. Thus, your total exposure time will slightly exceed what the test strip suggested—8 seconds in position number one, and 4 seconds in each of the five other positions.

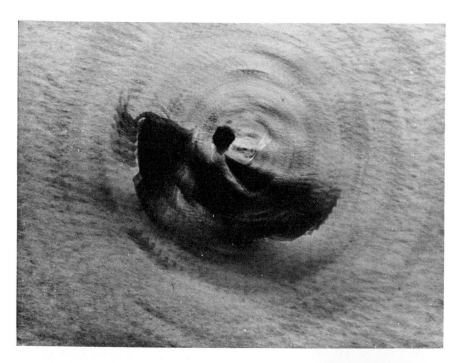

*With the matador's head serving as a pivot point, the enlarging easel was moved in a semicircular pattern to emphasize the subject's motion. Photo by Kathy Wersen.*

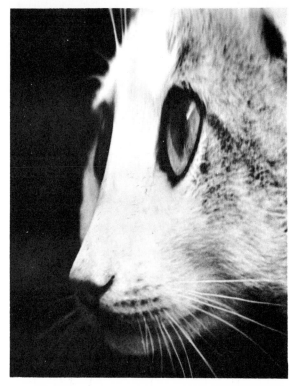

*This nosy cat was produced in the darkroom. The lower portion of the print was positioned closer to the enlarger lens to minimize the size of the mouth and elongate the distance between the nose and eyes. Photo by Norman Rothschild.*

# TURNING DAY INTO NIGHT

After a picture has been recorded on film there are still many controls left to the photographer which when carried out in the darkroom will add to the final interpretation of the subject. One of these is changing a twilight scene into day or night through the use of high contrast paper and/or dodging and burning in.

The New York scenic shown below and at the right was taken at twilight, about 15 minutes before it became dark. A normal print of the full negative did not capture the drama of the original scene and rather than give the negative up as a bad one, the photographer began to experiment. This led to the two completely different interpretations opposite. First, the normal print showed that a thin horizontal cropping would give more of a panoramic view of the city. This was the cropping chosen for both prints.

High contrast Agfa Brovira #6 paper was selected for the enhanced enlargement. An exposure time that would cast the buildings into semi-silhouette was used. During the entire exposure the sky was dodged to eliminate detail originally recorded on the negative. An extra one-third of the original exposure was given to the foreground street lights to emphasize the halo effect. This produced the stark daylight scene.

To create the night scenic a slightly longer exposure was given to the buildings, casting them as night silhouettes, but the sky was not dodged. Then, using the edge of an 8″ × 10″ piece of cardboard held down at an angle, the building area was dodged by continually moving the board while the sky was given added exposure. The printer's left hand occasionally moved over the U.N. building at the left and the tall building at the right, to simulate the halo effect around the other buildings created by the moving cardboard. Extra exposure was given for the sky, which was brightest in the upper right hand corner, for the foreground water and lights, and for the bright part of the General Assembly building, to burn in detail. Exposures were derived by test strip and practice.

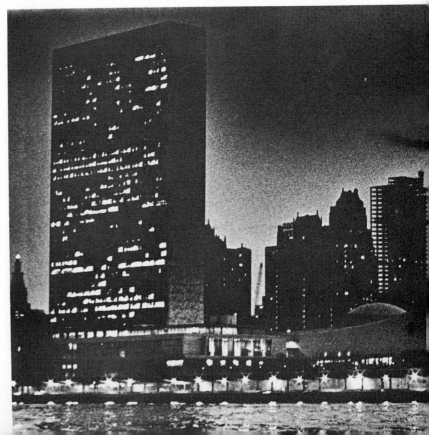

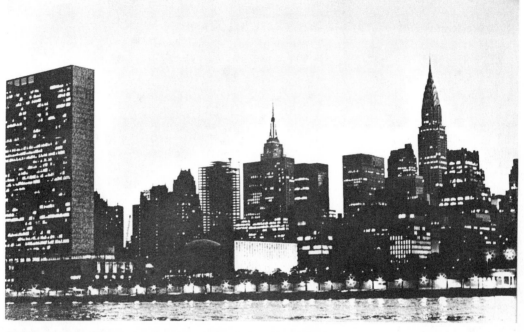

The two versions of the same scene were produced as explained in the text on the opposite page. Photos by Kathy Wersen.

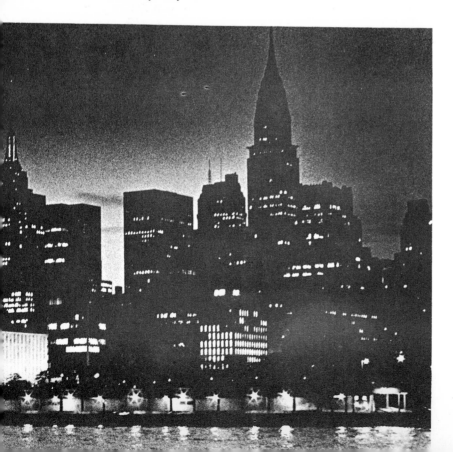

## RETICULATION

Reticulation, the wrinkling or cracking of the film emulsion by sudden changes of temperature during processing, is a technique that will ultimately give you yet another way to achieve a textured or patterned effect on the final print.

First, develop, wash, and dry the film in the regular manner—but do not use a hypo solution that contains a hardener or the emulsion may not respond. Dip the processed but unhardened film into hot (not boiling) water, and, after it softens, quickly transfer it to cold water to chill the emulsion. This process can be repeated several times until the emulsion has puckered to the extent you desire. Be sure not to hold the film in the hot water for too long or the emulsion can drip off the film completely.

Once the emulsion has reached the desired degree of reticulation move the film to a hypo solution with hardener, then rinse and dry in the normal manner. Reticulation patterns will vary from small, slightly irregular forms to large, well defined textures through longer processing. Portraits, still-lifes, and scenics are all excellent subject matter for this technique.

A final word of caution—don't practice reticulation on your favorite negatives! Either make copy negatives or use ones that won't upset you if they become ruined while you're learning.

*The textured pattern in the nude at left was produced by repeatedly dunking the negative into hot then cold baths. In a greater enlargement, the texture would be further emphasized. Photo by Lester V. Bergman/Photo Trends, Inc.*

## TEXTURE SCREENS

You can add extra charm and excitement to many of your pictures, even to those that leave you cold when printed straight, by using texture screens during the printing process. The screen will add an overall design or pattern to the paper, changing the original image into an artlike creation.

There are two ways this technique can be used: texture screens in direct contact with the printing paper, or texture screens placed in the negative carrier and projected onto the printing paper. For the former you can buy various kinds of texture screens from your photo dealer, or use ones you have made from tissue paper, nylon stockings, wire screens, and other household items. The latter technique involves photographing various textures on fine grain film and sandwiching these with your negative for a projection texture screen.

The screen can be left in contact for the entire exposure, or for part of it, depending upon the effect you desire. When exposing a print through a diffuser, remember that the larger the blow-up, the coarser the screen will become. And, increase normal printing exposure time for that negative by $1/4$ to $1/2$.

Develop a file of texture negatives by shooting interesting surfaces whenever you encounter them. Then you'll have a variety to choose from for that special print. Always be sure the screen selected is appropriate to the subject you are interpreting. A coarse screen for the portrait of a woman distracts rather than enhances, and you can imagine the effect of a delicate, lacy screen over the portrait of a rugged all-American type male! There is no hard and fast rule, however, which determines once and for all which type of screen goes with which subject. Let taste and experience guide you.

*Graphic-arts tone screens available in art supply stores were used to lend the regular overall pattern to the photo on the following pages. Photo by Rafael Fraguada.*

## TEXTURE GLASS

Rough-surfaced or patterned glass can serve much as the texture screen described earlier. Your local glazier has a wide variety of glass textures and surfaces for you to experiment with. The unusual patterns shown below were created under the enlarger by printing a normal negative through a piece of glass with a pebbled surface laid over the enlarging paper. When the pebbled side is face up the rough edges catch the light and spread it into a polka dot pattern, producing a lace effect, as illustrated in the picture at the left. When the pebbled side is face down, the light concentrates into many tiny points, forming a black-and-white rough-edged poin-tillism pattern.

Your regular enlarging paper can be used for these effects, but one with a slightly higher number or contrast will stress the design more. The accompanying pictures illustrate this difference. The softer one at the left was printed on #3 grade paper; the one at right, on higher contrast #5 paper.

Slightly longer printing times are required when you enlarge through texture glass. Correct exposures are best found by running a test strip. Experiment with paper developer strength, too. For example, Dektol diluted 1:1 will also add more contrast to the final print.

*The two prints on this page were made by printing through a sheet of pebbled glass. The softer print (below) was made with the pebbled surface down. The harder print (right) was made with the pebbled surface facing the enlarger lens. Photos by Lester V. Bergman/Photo Trends, Inc.*

*Smooth glass can also serve the creative print maker. For the print on the opposite page, a sheet of plain glass was smeared with Vaseline and placed on top of the enlarging paper while the print was made. Photo by Patricia Maye.*

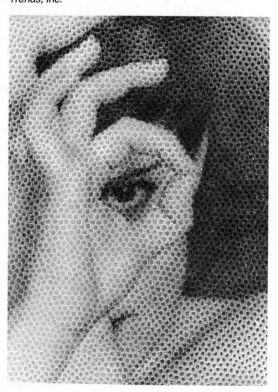

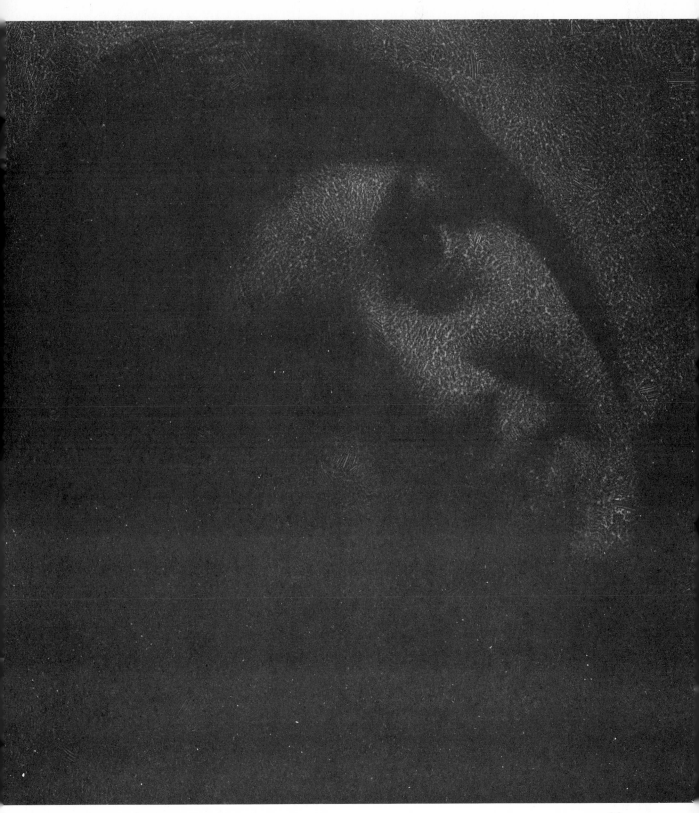

## PHOTOGRAMS

Photograms are the product of cameraless photography. They are silhouettes made by laying objects directly on photographic paper, which is then exposed to light. In their simplest form the images appear as pure white where the paper was covered and rich blacks where it was exposed—but the possibilities are endless. You can concentrate on the patterns made by many complex objects, or you can bring additional interest to a few simple shapes by creating variations in tone through the use of screens or different exposures. Fernand Fonssagrives created a startling design (page 63) by having his model place her head on the paper under the enlarger. Then he arranged her hair until he saw a design he liked.

Use a contrasty paper (grade number 4, 5, or 6) for your photograms. If your easel prevents an object of your choice from lying flat on the paper, or if you prefer a borderless print, fasten the paper down on the enlarger base with a dab of putty under each corner of the paper. Center the paper under the enlarger light by a red over-the-lens filter, then gently press the corners down on the board.

If you want to use a texture screen, lay the screen on top of the paper, then run a test strip, exposing at three different times—such as 15, 30, and 45 seconds—to determine the correct exposure. The final print is made by first centering the paper, then placing the screen, and finally laying the objects on the screen by the light of the enlarger safelight filter until you strike upon a composition you like. If your enlarger doesn't have a safelight filter, tape a piece of red cellophane over the lens and remove just before exposure. If you want some tone in the white object areas, remove the objects after exposure and burn in these areas, while carefully dodging the rest of the picture. By consulting your test strip, and removing objects at a prescribed moment, you can obtain any shade from light gray to deep black.

Cut-out shapes of thick, dark paper can also be used in creating photograms. Suppose you cut out the shape of a cat. If you want the cat to appear white, lay the cut-out on top of the enlarging paper. If you want a black cat, lay the piece of paper from which you cut out the cat on top of the enlarging paper. After exposing through the cut-out for a black cat, the top paper can be removed and other objects recorded in the previously unexposed sections. Or, you can print this area for varying shades of gray.

Objects made of clear or translucent plastic are other subjects which will give fascinating shadowy shapes. As always, run test strips to find the proper exposure.

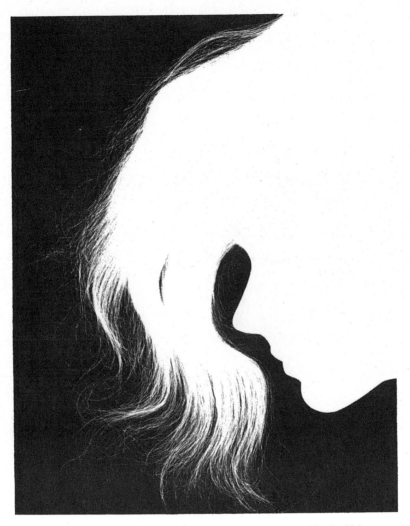

The model's head and hair were placed on the printing paper to make the high contrast photogram above. Photo by Fernand Fonssagrieves.

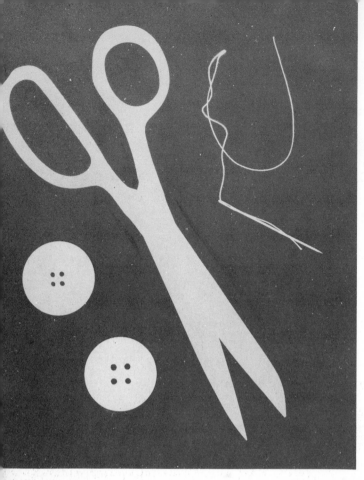

Photograms can be made by using real objects or they can be entirely abstract. The two designs on this page were produced by placing household items—a pair of scissors, buttons, and a needle and thread—in contact with the paper. For the print below, a texture screen was added for texture and the objects removed one by one after the basic exposure to produce the different tones. The photogram on the opposite page was produced by less controlled means. A large piece of waxed paper was crumpled, placed over the printing paper; then the exposure was made. Photos by Patricia Maye.

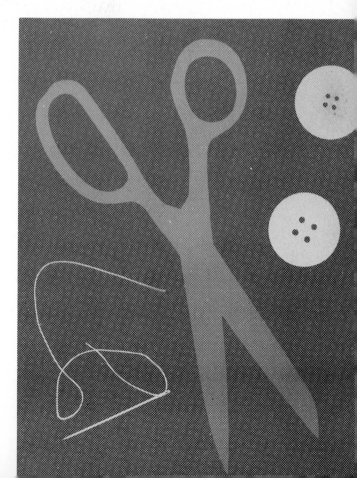

## FLOPPING

Printing a negative, then flopping or turning it over and printing it in the reverse direction, will often convert an ordinary picture into an extraordinary one. This is also a way to create a picture that gives the impression of a subject and its reflection in a mirror. For the photograph below Norman Rothschild took an off-beat negative, and using the darkroom technique of flopping, came up with his impression of architecture in Greenwich Village, New York City.

There are two methods of making a photograph by flopping. The first method consists of making two prints—the first printed in the normal manner; the second with the negative turned over so it is reversed left to right—then carefully trimming the prints and pasting them end to end and making a copy negative for the final print. In the second method the negative is first printed normally on one half the enlarging paper while the other half of the paper is covered. Then the negative is flopped and printed again on the other half while the previously exposed section is covered. To be sure the two pictures fit exactly, place two pieces of cardboard on top of the easel and connect them down the center with a piece of tape. Be sure they fold back to back easily. Then, covering the enlarging paper with the cardboard, fold one side back over the other to make the first exposure. Close, then open the other side for the flopped exposure.

*The flopped print at left conveys the photographer's impression of the architecture in New York's Greenwich Village. Two prints were made, one with the negative in the normal position, one with the negative reversed. The prints were then carefully trimmed at the center line, mounted together, and a copy neg made for the final print. Photo by Norman Rothschild.*

## HIGH AND LOW KEY

High- and low-key effects are more "creative" than "trick"; utilized properly they can result in pictures that are real eye-stoppers! The difficulty is in recognizing these two forms of subject and lighting, then knowing how to use them. These two photographic techniques are used practically every day in the work of the professional photographer, but they are most often overlooked as a means to unusual photographs by the amateur.

High key refers to a light photograph containing a predominance of whites and light grays, with an absence of full dark shadows. It has softness of contrast and a delicacy of tonal gradation and is especially appropriate to portraits of women and children.

Low key refers to a photograph at the dark end of the tonal scale—running predominantly to the dark grays and blacks. It emphasizes the mood of mystery, night, loneliness, fear.

There are also interesting pictures to be made employing the starkness of high-key whites and low-key blacks in one picture, with few middle tones. This combination requires a dark subject and light background—or the reverse—with flat lighting to avoid shadows. Take the meter reading from the darkest area of the picture so the highlights will be slightly overexposed. Use a high contrast paper such as Agfa Brovira #6 for the final printing. This paper produces the blackest blacks and the whitest whites of any paper available. If there is too much detail in the dark areas, these can be burned in during printing for greater tonal contrast.

Perhaps the easiest way to achieve a high-key effect is to expose for the darkest area in your picture, using a soft, even light, such as bounce flood or diffuse daylight, which reduces shadows to a minimum. Or position the light source behind the camera, just over the right or left shoulder. To achieve a completely high-key picture the subject and background must be light and have a low range of tonal contrast. Print high-key pictures on a normal #2 or #3 grade printing paper. Give a short exposure and develop for a longer period of time in a weak or low contrast developer, such as one part Dektol mixed with two to four parts of water.

*A dark background and harsh side lighting combine in the portrait below to create a somber, low-key effect. Photo by Kathy Wersen.*

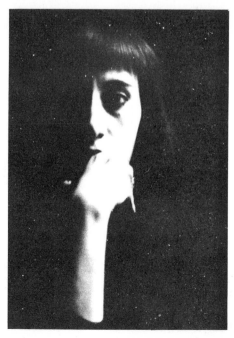

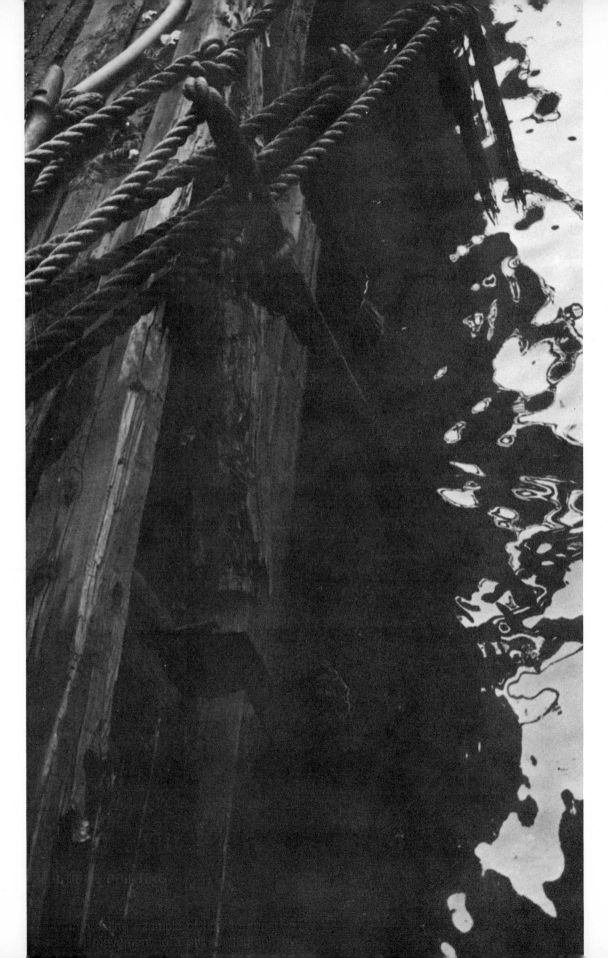

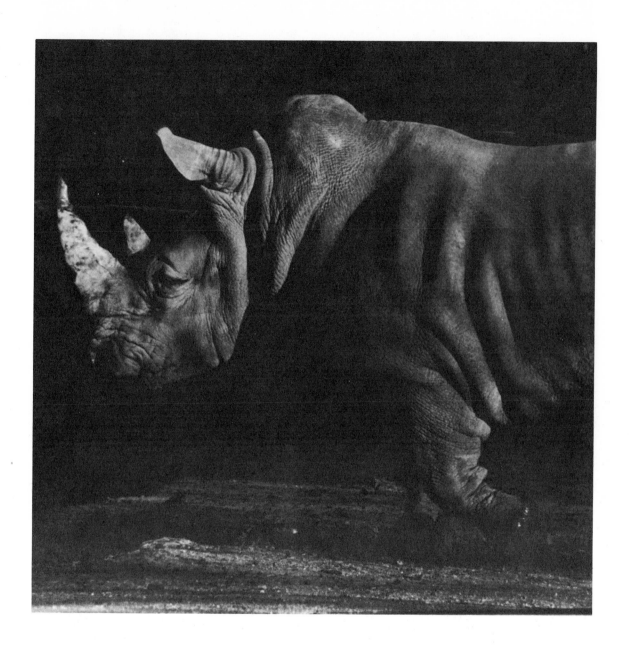

*The two photos on these pages give a moody effect. The wharf edge at left was photographed on a bright sunny day and the bright highlights in the water were deliberately cropped from the final print except along the very edge. The rhino above was photographed by late afternoon sunlight. The print was made deliberately dark and background highlights touched out to keep the low-key look. Photos by Rafael Fraguada.*

## PHOTOLITH

A woodcut, charcoal, or pen and ink drawing effect can be achieved photographically by using high contrast copy film in a variety of ways.

One—make an 8 × 10 print from a normal negative. Tape the back of the print onto a wall or white no-seam paper. Place two lights at a 45-degree angle and about 30 inches from the print to provide an even, glareless light with no shadows. Photograph the print on high contrast copy film or Kodalith. Most of these films can be successfully developed in Dektol 1:1. The film data sheet will give you specific instructions.

Two—make a contact print. Place a normal negative in a printing frame with the emulsion side up. Then place the Kodalith film over the negative, emulsion side down. Using the enlarger as a light source, make a test strip for 1, 2, 3, and 4 seconds, then develop. Examine your test strip for the correct exposure. Now expose and develop a new piece of film for the correct time. This will give you a high contrast diapositive, the reverse of a negative. The high contrast negative is then made by contacting with the positive, emulsion to emulsion in the print frame. Litho films used this way often produce pinholes. After the negative is dry, these can be painted out with red or black opaque on its shiny side.

Three—photograph the original scene using a photolith film. Kodak's high contrast copy film, available in 35mm size, has a suggested ASA rating of 64. In anything other than bright, contrasty lighting, it is better to rate it at 40 ASA. This is also developed in Dektol 1:1.

Four—enlarge your negative on photolith film for a high contrast positive. Then, contact print it to create the high contrast negative.

These processes will all bring you to the same point—a high contrast negative, minus middle tones. The final prints can be made on any normal grade paper and developed in Dektol 1:2. We find that we get a more delicate ink drawing effect using normal paper through contrast grade #4. A bolder, charcoal drawing effect can be achieved by using #5 or #6 paper.

*The dog on the opposite page began as a high contrast negative. The neg was printed onto Kodalith film and a newspaper mask cut to fill in the area of the dog's body. The mask was mounted on the back of the Kodalith positive, then the two layers were mounted on a sheet of white drawing paper. Photo by Patricia Maye.*

## SOLARIZING A NEGATIVE

The result of exposing partially developed film to a light source—by design or accident —is solarization, a partial reversal of the negative image. (The true name of this reversal phenomenon, "Sabattier Effect," is seldom used anymore.) The highlights remain clear and unaffected but the middle tones will fog and black areas reverse to white. The printed result from a solarized negative defines all objects in the picture with a strong, black outline. The effect is most easily obtained with subjects having well defined masses of light and dark.

To solarize your negatives, develop them for $1/2$ to $2/3$ the overall time, then remove from the developer, rinse quickly, and wipe off the excess liquid to make sure that spots or bubbles of developer do not leave their impression later. Hold the film about three feet away from the safelight and expose it for about ten seconds. Then return the film to the developer and finish processing. Dense negatives will require slightly more exposure time to the safelight and thinner ones less. Slower films also require more safelight exposure. Experimentation will prove which ratio of development to fog time will give you the particular result you desire.

Contrasty film is the easiest to work with. Remember that the more the film is fogged, the contrastier the printing paper should be in order to get a snappy print. Solarization will lend a note of mystery, or the supernatural, to your interpretation of a subject.

*The solarized cat above was printed from a negative that was accidentally solarized during processing. This is hardly the best way to proceed but in this case the light-struck roll did yield a few printable negatives. The eerie shift of negative and positive areas and the strange isolating line around highlight areas is apparent. Photo by Patricia Maye.*

## SOLARIZING A PRINT

Solarizing a print is more tricky than solarizing a negative because prints tend to quickly go very flat and dull gray. However, solarizing with a print eliminates the risk of ruined negatives. If the effect proves unsuccessful your negative remains safe and unaffected for another try. Choose only a contrasty negative to work with. First expose for a normal print, but use enlarging paper two or three grades more contrasty than normal. Give full development in a contrasty developer such as Dektol 1:1, then transfer the print to a tray of one part developer to about 80 parts of water for about one minute so it will be less sensitive to the light. Remove the print, squeegee the surface, and flash a 25-watt bulb about five feet away on, then off, as fast as possible. Return the print to the tray of weakened developer until you see the image you want (by safelight). This will usually take two to four minutes. If a print is flashed while in strong developer, the solarization takes place too quickly and the print will fog out. The print can also be flashed while submerged in the tray of weak developer, while the tray is gently agitated. The liquid movement will appear on the print as smoke or fog—another interesting effect, providing it doesn't obliterate the main subject.

*The two prints opposite are an unsolarized (top) and solarized (bottom). To make the solarization, the print was first made on high contrast lith film. The high contrast positive was then printed onto high contrast paper and while this second print was in a tray of weak developer, it was briefly exposed to light. Development was then continued for an additional $3^1/_2$ minutes. Photo by Gerald Healy/Photo Trends, Inc.*

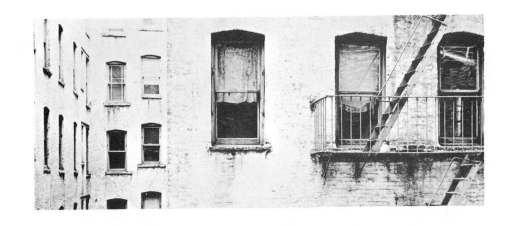

75

## PAPER NEGATIVE PROCESS

Interesting pictorial effects are easily created by means of the old and established paper negative process. A paper negative is literally a contact print having a negative image, made in direct contact with a positive print. By means of the techniques described, you can end up with a negative image for its own sake, or go on to make positive prints with many variables.

Since the paper negative process builds contrast as you move through each of the steps, it is best to start out with a rather soft original negative or the softest possible enlarging paper in making the first enlargement. Contrast can also be lowered by using a weaker solution of developer such as Dektol 1:4 instead of the usual 1:2 dilution.

The first print is made in the enlarger to the size and cropping desired for the final result. Single-weight paper is easier to work with because it more easily transmits light for the next step than double-weight paper. Process and dry this print, then place it face down (emulsion to emulsion) on top of a fresh piece of sensitized paper on the enlarger baseboard. To insure absolute contact of the two surfaces for a clear print, place a piece of glass on top, or work with a printing frame. Then, using the enlarger light, expose for the second negative image and develop. Exposures usually run from 5 to 10 times longer for paper negatives as compared to projected prints, so determine all exposure times by test strips.

At this point you can stop and enjoy the result, or go on to make a positive print from the paper negative. This is done by contacting the negative print onto still another sheet of enlarging paper. This is a particularly valuable and fast technique when you have a number of prints to make from a small size negative. Considerable control over the final results can be obtained by retouching on the backs of both negative and positive with a pencil. Anything that is to be darkened on the final print is retouched on the back of the first *positive* print (for example—an obtrusive background). To lighten areas, darken these sections on the back of the *negative* image. Since pencil marks are diffused by printing, your crudest efforts at retouching will seldom show up as anything but fine pictorial effects.

The use of different textured printing papers will also vary the texture of the final print. For instance, a silk-finish paper gives a fine grain effect. Agfa Brovira #5 and #6 will give a grainy effect. Also, paper negatives made on double-weight papers will register the texture of their paper fibers on the contacted print more than single-weight papers. The paper negative process can be used as a functional or pictorial tool.

## BAS-RELIEF

Bas-relief printing involves sandwiching a positive film image together with a negative of the same subject, slightly out-of-register, to produce a raised or three-dimensional optical effect in the print. The subject looks as if it was carved out of stone rather than photographed, for shadows that appear around the edge of forms seem to make them stand out. The subject matter for bas-relief pictures should be linear, uncomplicated, and well defined. The negatives need to have clear-cut, sharp outlines and good contrast.

A positive film image can be contact printed from the original negative (as described under photolith process, page 71), except you will use any normal contrast film rather than the high contrast photolith. For a successful result, you should aim for a diapositive of the same density as the original negative.

Lay the positive transparency emulsion side up on the negative carrier or a piece of glass. Then place the original negative emulsion side down and slightly out-of-register over the transparency. Now hold the two pieces of film in this position up to a light to decide which way you want them to overlap. Tape the two pieces of film down to the negative carrier or to the piece of glass to maintain the alignment. Then slide the negative-positive sandwich into the enlarger.

Use a high contrast, high number paper for making the final print. (Normal paper will give you gray, flat tones through the two negatives.) A test strip will help you to arrive at the best exposure time. The degree to which you place the diapositive and negative out-of-register will depend upon your own taste; the greater the offset, the greater the depth—but the illusion will be lost if the offset is too great. Notice that around every figure in the scene there will be a light or transparent area where the figures fail to meet; where they overlap there will be a dark area. The light and dark areas around the figures will appear as highlights and shadows to create a strange illusion of depth.

*Negative and positive film images were sandwiched together slightly out of register and printed to produce the fine line portrait at right. Photo by Fernand Fonssagrieves.*

## POSTERIZING TECHNIQUE

This is an off-beat variation of the photographic process similar to the photolith technique, which reduces normal gradation prints to strong masses of black and white. However, posterization or tone separation, as it is also called, not only produces strong whites and blacks but also sharply defines one or two middle tones, creating a designy poster effect.

Any size normal negative can be used, but it is best to choose one with strong design. The process involves making two or three high contrast separation negatives and exposing one piece of printing paper through each of the separation negatives, beginning with the thinnest shadow negative, one after the other, in exact register or alignment.

The first step in separation is to make an enlarged diapositive or a film positive from the original negative to the size of the desired final print. Project the original negative onto a normal film such as Kodak Fine Grain Positive, which can be developed under an OC or 55X paper safelight and in paper developer. Its speed is about twice

that of ordinary enlarging paper, so stop the lens down. You can develop in Dektol at about 1:4 or 1:7. Watch development under the safelight. Aim for low contrast.

Now, using high contrast litho film, make three negatives: "a" is dense to record the highlights only; "b" is half transparent and half dense in the middle tones and receives half the exposure for the "a" negative; "c" is thin to record the shadow areas and receives $1/4$ of the exposure of the "a" negative. To maintain proper register, contact each negative from the diapositive by using a registration board. To make one, take an $8 \times 10$ piece of mounting board (for $8 \times 10$ paper) and push a thumbtack through the upper left and right hand corners about $1/8$ inch in from the top and one inch in from the side. Turn it over, then center the films and paper as you use them and push down on the pins. Double-faced Scotch tape on the back of the board will hold it in one place under the enlarger. Fix, wash, dry, then spot negatives for any unwanted pin holes, etc., with India ink or opaque retouching color.

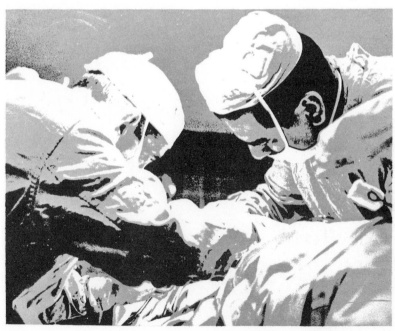

To make a poster print, make a test exposure first with the "c" negative. Place a normal grade of enlarging paper, emulsion side up, upon the registration board. Place the "c" negative emulsion side down on top and make several exposures. In Dektol 1:1 develop to a light gray (first density on Eastman paper gray scale) and note exposure and development times. Assume the exposure for the "c" negative is four seconds. Now once again, with fresh paper, expose the "c" negative at four seconds, then remove. Next, place the "b" negative, being careful to maintain registration. Expose the "b" negative for 10 seconds on the same paper for middle tones, then finally the "a" negative for one minute. Develop and check to see if you need to alter any of the three exposing times because of misplaced tones. Use the ratio of 4 seconds to 10 seconds to 60 seconds as a general exposure ratio guide for the three negatives. Remember that the negative of greatest density receives the most exposure.

*The two posterizations shown on these pages were made by using three negatives as described in the accompanying text. For the print on this page, the negatives were opaqued to eliminate unwanted details in the sheet, on the doctor's cheek, and on his gown. Photos by Kathy Wersen.*

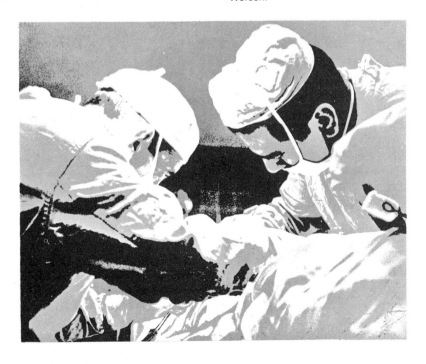

## MULTIPLE PRINTING

An interesting example of how to impart a sense of movement to a still photograph by means of overlapped multiple images can be seen in Norman Rothschild's kittens shown at the right. You can duplicate this effect by making a series of exposures on one sheet of enlarging paper. Contrasty paper will help keep the outlines of a well defined image. A radial or movement effect is obtained by rotating the paper, a short distance at a time, around an imaginary axis in the center of the paper.

First run a test strip to determine the correct exposure time for a straight print. Then divide the total print time by the number of individual exposures to be made. Thus, if the correct exposure for a normal single print is 20 seconds and you wish to make five exposures with the easel in different positions, give each exposure movement four seconds. You can begin with the correct centered position of the subject, or start from one side and move to the other.

Many interesting abstract forms can be obtained through multiple printing depending on your subject matter and how you move the easel. Other effects can be created by flopping the negative, combined with easel movement. By taking a negative and printing it several times without overlapping on a single sheet of paper you can create another variation of multiple printing. See the photo "Gossip" at the bottom of page 25 for example. This picture was made in the camera, but if the photographer had wanted only one expression on the model's face he could have achieved a similar effect by using one negative and printing it several times on the same sheet of paper.

*The kaleidescopic cats shown here are the results of multiple printing of a single negative. Photos by Norman Rothschild.*

# 5

# GALLERY

# A PICTURE GALLERY

Throughout this book, an attempt has been made to isolate individual examples of the creative techniques described. But in practice, creation and isolation are not near neighbors. As you progress with your experiments and novel shooting techniques you may well find yourself combining methods and materials to new and improved effect.

The photos reproduced on the following pages display combinations of techniques, unorthodox methods not described earlier in this book, and some rather free thinking on the parts of the photographers who executed the prints.

You may wish to look over this section without consulting the descriptive captions which follow. Give it a try and see if you can figure out what techniques were used to produce the novel end products. Then, check your assumptions out against the following information.

*The photo on page 83 was taken in the early evening in sculpture garden at the Museum of Modern Art in New York. The bright backlighting reduced the sculpture to a silhouette. The backlit figures in the doorway are out-of-focus and thus lose their edges. A slow shutter speed also allowed the people time to move and they thereby became even less distinct. The print was made on high contrast paper to enhance the effect. Photo by Patricia Maye.*

*The photo on page 84 began with a normal portrait negative. The enlarging paper was positioned in the printing frame and dabbed with developer applied with a crumpled washcloth. As the printing exposure was made, the mottled image began to emerge. When the simultaneous exposure and development reached the desired point, the enlarger lamp was switched off and the print put directly into the stop bath. Photo by Patricia Maye.*

*Two techniques described earlier—high key and screen printing—combine in the photo on page 85. The same negative used for the print on page 84 was here underprinted through a texture screen. The airy effect please both the subject and photographer. Photo by Patricia Maye.*

*Again, the negative used for pages 84 and 85 was the starting point for the print on page 86. This time a normal printing exposure was made and conventional development begun. After the print was in the developer about one minute, an overhead lamp was turned on for ten seconds. This after exposure caused the light areas to fill in with a flattering flat gray tone. Photo by Patricia Maye.*

*The print on page 87 was made by giving the paper a normal enlarging exposure then swabbing it with developer applied with a wad of cotton. As soon as the streaks began to develop the print was put into the developer tray and given an overall, but short, development. The effect aimed at and achieved was to gain a dreamy, underwater look. Photo by Patricia Maye.*

*The print on page 88 shows the delicate elegance that can be achieved through the solarization process. The print was made on extra-hard-gradation paper to emphasis the effect. It was created by Andreas Feininger, one of the world's finest photographers and printmakers and appears in his book* Darkroom Techniques, Volume II *(Amphoto, 1973).*

*The print on page 89 is by Andreas Feininger and appears in the same darkroom volume. It was made from a solarized paper negative and printed on soft-gradation enlarging paper to maintain the texture of the paper negative. The books* Darkroom Techniques, Volumes I and II, *are heartily recommended to anyone interested in darkroom image manipulation.*

*The two portraits on pages 90-91 were produced through the intervention of high-contrast Kodalith film. A series of high contrast negatives and positives was the starting point. Three negatives of increasing density were combined for the posterization on page 90. The lightest negative and lightest positive were sandwiched and printed for the line effect on page 91. Photos by Patricia Maye.*

*The tiny insect shown greatly enlarged on page 92 was printed by direct projection onto infrared film. A reversal film was made and the positive and negative images sandwiched together for a bas-relief print with three-dimensional effect. Photo by Andreas Feininger from* Darkroom Techniques, Vol. II.

*The photo of the shoreline and boats on page 93 was taken with the deliberate intention of visualizing the spectacular shift from low to high tide at Passamaquoddy Bay, Maine. The rowboat was tied to the pier and photographed twice from the same camera position—once at high tide, once at low. The combination print shows the possibilities of a well thought out, carefully photographed, and finely printed combination. Photo by Andreas Feininger from* Darkroom Techniques, Volume II.

*The last print, page 94, is also a combination. The face is the same used on page 49. Here it was printed into the blank sky area of a shot taken directly into the sun. Photo by Patricia Maye.*

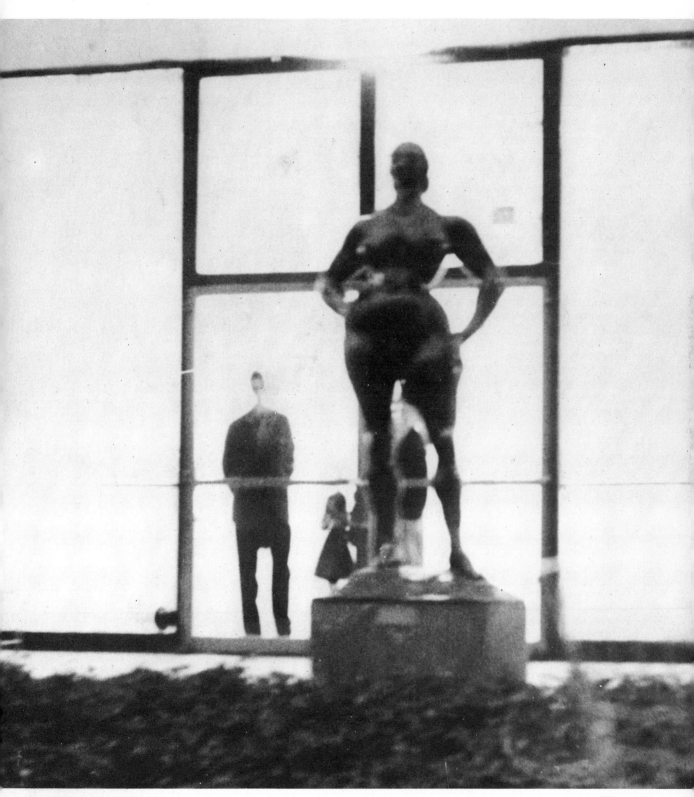

*Photo by Patricia Maye*

*Photos by Patricia Maye*

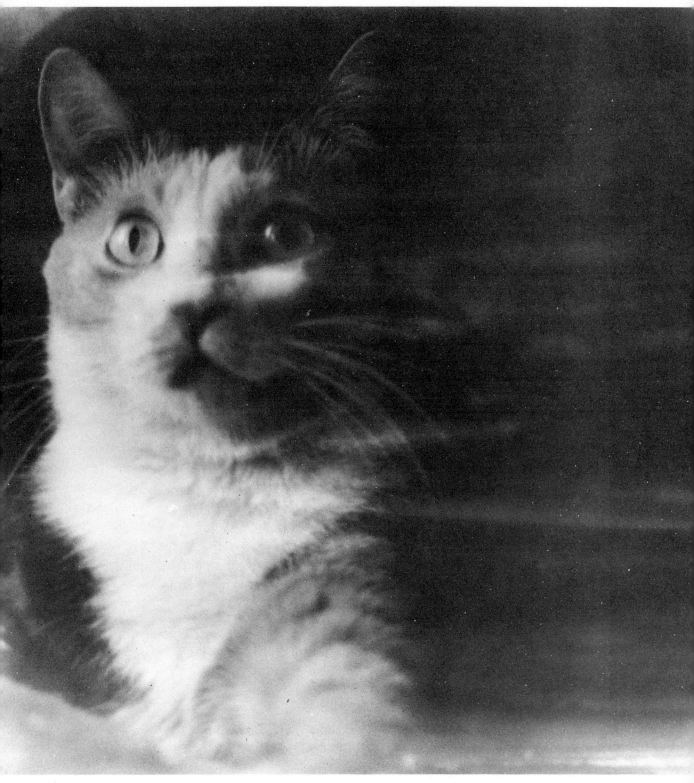

*Photos by Patricia Maye*

*Photos by Andreas Feininger*

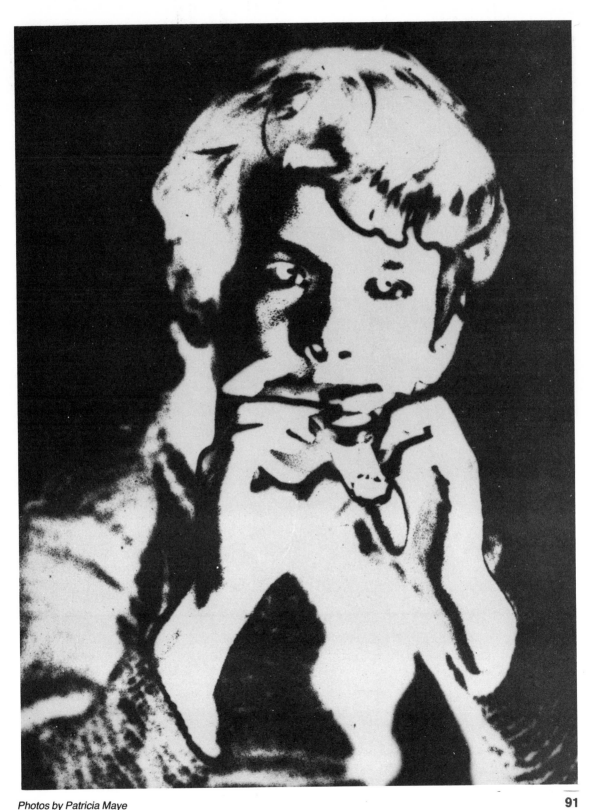

*Photos by Patricia Maye*

*Photos by Andreas Feininger*

*Photo by Patricia Maye*

**6**

**CREATIVE COLOR**

# CREATIVE COLOR

By extending his photographic bag of tricks to include color, any photographer will extend the possibilities for beautiful and enjoyable results. Most of the techniques described earlier in this book and illustrated with black-and-white results, will lend themselves equally well to color.

Certain special care must be taken when color materials are used. Exposure must be more exact than with black-and-white films—the exposure latitude of color films is not as broad as that of black-and-white. Shots that rely on shallow depth of field or out-of-focus forms for their strength must be more carefully previewed. A brightly colored object in the foreground of background can seriously detract from your intended emphasis; even though it is out of focus, its color contrast will make it stand out and command attention.

You can use either color negative or slide films for your color improvisations. Buy color negative film if you plan prints as your end result—color slide film if you want slides for projection.

Owing to the limitations of space, only a few color possibilities can be included here. In each example color is a positive factor. For example, the reflection photo opposite would have been a rather uniform gray if photographed on black-and-white film. In color, the lovely blue sky and gray buildings separate from each other.

The photo sandwiches that follow were assembled by overlaying color transparencies. Sandwiching images is made a great deal easier by working with positive materials. You need only have the imagination to contrive a combination of two of your slides, a light source in front of which to view them, the dexterity to twiddle with the alignment until the overlap pleases you, and some tape to maintain that overlap once-and-for-all.

The last page of the color section shows two examples of "misused" materials. Color infrared film is used primarily for scientific applications. It can however be used for landscape and portrait studies with that special something.

Unlike black-and-white films that are standard no matter what the light source in use, color films are balanced for use with daylight or tungsten lighting. As with the infrared films mentioned above, misuse of specially color-balanced films can be a pathway to creativity.

As suggested in the introduction to this book, the rules of right and true cannot always dominate the creative photographer. Expression is as powerful a motivation in photography as it is in the other arts. Hopefully, the photo examples and text suggestions given throughout this book will lead you to photographs that are more personally yours whether your end purpose be to conjure up mood or mystery or merely to have fun with your camera.

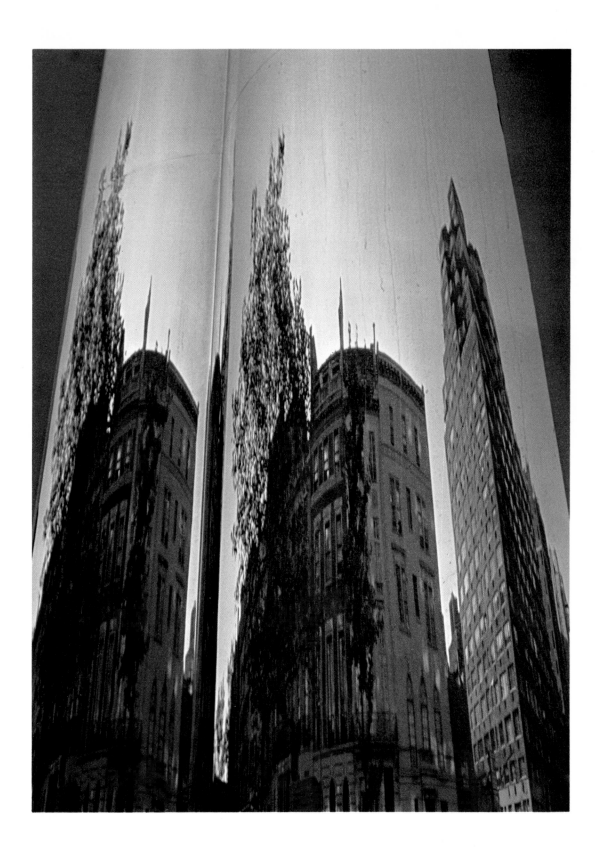

*(preceding page) The elongated multiple image of the buildings was made by photographing them in two reflective pillars across the street. Exposure was normal and made through a 35mm Miranda lens on Agfachrome film. An imaginative viewpoint is the only trick involved in creating this interesting and successful photograph. Photo by Rafael Fraguada.*

*Combining images, either during the act of shooting or after the fact, opens up avenues of new creative potential to any photographer. The two combination photos on these pages are "sandwiches"—two color slides superimposed on each other. To create the image above, a straight photo of a sculpture was sandwiched with one of the rough surface of a roadside ditch. At right is a combination of a head shot with one of a frothy sea wave washing over some rocks and shot from above. Photo above by Harushi Tetsuka. Photo opposite by Patricia Maye.*

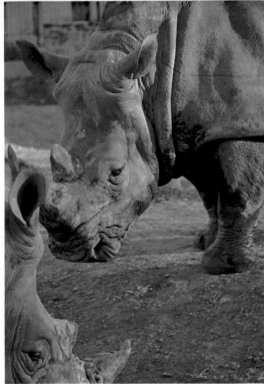

*Sometimes the "wrong" materials or techniques can be used to produce a "right" result. The portrait above was shot on Ektachrome IR (Infrared) film while the rhinos at right were taken by natural daylight on High Speed Ektachrome Type B (tungsten) film designed to be used under artificial light. Photo above by Robb Smith. Photo right by Patricia Maye.*